FAIRY TALES, MONSTERS,
and the GENETIC IMAGINATION

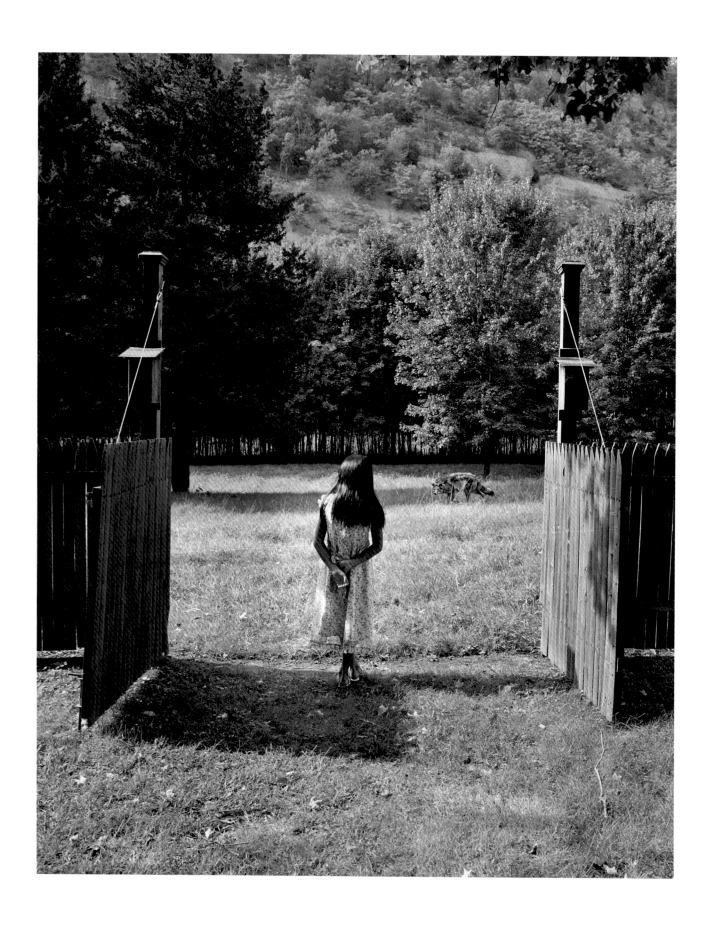

Fairy Tales, Monsters, and the Genetic Imagination

Edited by
MARK W. SCALA

Essays by
SUZANNE ANKER
MARK W. SCALA
MARINA WARNER
JACK ZIPES

FRIST CENTER FOR THE VISUAL ARTS

VANDERBILT UNIVERSITY PRESS

Nashville, Tennessee

© 2012 Frist Center for the Visual Arts
All rights reserved.
Published by Vanderbilt University Press
First printing 2012

This book is printed on acid-free paper.
Manufactured in China

Library of Congress CIP Data on file.
ISBN 978-0-8265-1814-9

Cover design by Bruce Gore | Gore Studio, Inc.
Text design and composition by Dariel Mayer

Front cover illustration: Patricia Piccinini, *The Long Awaited*, 2008. Silicone, fiberglass, human hair, leather, plywood, and fabric; 36 ¼ x 59 ⅞ x 31 ½ in. overall. Collection of Penny Clive, Australia. Photo by Graham Baring.

Frontispiece: Amy Stein, *Predator*, 2006. C-print, 37 ½ x 30 in. Courtesy of the artist and Brian Clamp Gallery.

Back cover illustration: Paula Rego, *Nursery Rhymes: Little Miss Muffett III*, 1989. Etching and aquatint, 9 x 8 ½ in. (image), 20 ½ x 15 in. (sheet). Edition 49 of 50. Marlborough Graphics, New York.

This catalogue is published in conjunction with the exhibition *Fairy Tales, Monsters, and the Genetic Imagination*, organized by the Frist Center for the Visual Arts, Nashville, Tennessee (*www.fristcenter.org*).

EXHIBITION ITINERARY

Frist Center for the Visual Arts, Nashville, Tennessee
February 24–May 28, 2012

Winnipeg Art Gallery, Winnipeg, Manitoba, Canada
June 14–September 9, 2012

Glenbow Museum, Calgary, Alberta, Canada
September 28, 2012–January 2, 2013

contents

Frist Center for the Visual Arts

FOREWORD *and* ACKNOWLEDGMENTS

This catalogue is published in conjunction with *Fairy Tales, Monsters, and the Genetic Imagination*, an exhibition organized by chief curator Mark W. Scala that explores some of the ways that artists have engaged the body's endless mutability in generating a vocabulary of paradox. Moving from tangible bodies to imagined ones, the exhibition brings together contemporary works that are inspired by literary and oral traditions, as well as by newly emerging branches of science, in which human and animal collide to yield a third force, which encapsulates the multiple nature of self and society.

Inspiration for this exhibition came from many sources; it began with the anthropomorphic sculptures and thoughtful writings of Patricia Piccinini, whose meditations on issues surrounding genetic manipulation evoke the composite creatures of legend and lore. It was solidified through the scholarship of Jack Zipes and Marina Warner, whose brilliant exegeses on the origins and psychosocial meanings of folklore and supernatural projections have helped bring these subjects closer to the center of discourse in the humanities. And it was expanded into the realm of science and futuristic speculation by the work of Suzanne Anker and Dorothy Nelkin, whose magisterial book, *The Molecular Gaze: Art in the Genetic Age*, explores the aesthetic, social, and ethical dimensions that accompany the invention of bodies in real-time,

laboratory-cum-studio settings. Adding their intellectual heft to Scala's speculative linking of old and new through the lens of contemporary art, Zipes, Warner, and Anker have all contributed essays to this publication. At the same time, they have offered guidance to Scala in his selection of artists and articulation of themes. We are extremely grateful to them for their generosity, enthusiasm, and insight.

This catalogue, published by Vanderbilt University Press, offers a textual and pictorial analysis of the history and possible meanings contained in these updated expressions of the gothic imagination. Thanks especially to the Press's director, Michael Ames, whose own interest in expressions of alterity through fantasy matches perfectly the tone of the exhibition. Appreciation too goes to Jessie Hunnicutt, freelance copy editor, and Dariel Mayer, design and production manager.

A group of Vanderbilt University professors from disciplines including anthropology, German studies, history, and philosophy, who meet regularly to discuss humanity's relationship with animals, was instrumental in shaping some of the ideas informing the exhibition. Our thanks to Michael Bess, Beth Conklin, Colin Dayan, Sara Figal, Lisa Guenther, Kelly Oliver, Benigno Trigo, and David Wood for offering the perspectives of their own fields of study. Further research assistance was provided by Andrea Immel, the curator

at Princeton University's remarkable Cotsen Children's Library. At the Frist, interns Courtney Wilder and Elyse Sadhegi assisted with research.

We are grateful to the following gallerists, curators, and studio representatives, who were extremely helpful in identifying works for the exhibition and facilitating the subsequent loans: Teneille Haggard, Andrea Rosen Gallery; Vicki Gambill, Maria Aimerito, and Joanne Heyler, Broad Art Foundation; Claire Oliver, Claire Oliver Gallery; Donna Chu, Stephanie Daniel, Bellatrix Hubert, and Carolyn Ramo at David Zwirner Gallery, New York; Derek Eller, Derek Eller Gallery; Courtney Tennison, Dunn and Brown Contemporary; Louise Déry, The Gallery of the University of Quebec, Montreal; Jessica Uelsmann and Thomas Southall, Harn Museum of Art, University of Florida; Emilio Steinberger, Haunch of Venison Gallery; Stephanie Fitzpatrick, Heather and Tony Podesta Collection; Laurie Harrison and Elyse Goldberg, James Cohan Gallery; Stephanie Smith and Amanda Schneider, Lehmann Maupin Gallery, New York; Kim Schmidt and Emily Edison, Marlborough Graphics, New York; Stéphane Aquin, Montreal Museum of Fine Arts; Emily Talbot and Deborah Wye, Museum of Modern Art; Vanessa Lopez and Wendy Olsoff, P.P.O.W. Gallery, New York; Sarah Stout and Rick Wester, Rick Wester Fine Art; Tayo Ogunbiyi, Jeanette Sisk, and Susan Dunne, Pace Gallery; Roger Moll and Mary Anne Nairne, Patricia Piccinini's studio; Roslyn Oxley, Roslyn Oxley Gallery; Michael Jenkins, Sikkema Jenkins Gallery; Silvia Davoli, Skarstedt Gallery, New York; James Salomon, Salomon Contemporary; Maryse Brand and Angela Westwater, Sperone Westwater Gallery, New York; Ann Sanchez, Stéphane Janssen Collection; Mariko Munro, 303 Gallery, New York; Jan Minchin, Tolarno Galleries; Joann Kim, Janaina Tschäpe's studio; and Nao Sakai, Yamamoto Gendai Gallery, Tokyo.

We also thank the lenders to the exhibition, listed on page xi, who have temporarily sacrificed their own spine-tingling pleasures so our audiences can enjoy the loaned works for the duration of the tour. We gratefully acknowledge the participation of the Winnipeg Art Gallery, whose director, Stephen Borys, and chief curator, Helen Delacretaz, enthusiastically embraced the project during the planning stages. Equally ardent in their support have been the Glenbow Museum's CEO and president, Kirstin Evenden, and vice president for access, collections, and exhibitions, Melanie Kjorlien. We are honored to share this exhibition with two such distinguished venues.

We remain ever grateful to our trustees, who enthusiastically support our commitment to offering high quality and compelling exhibitions, programs, original scholarship, and interpretation that will enable our audiences to "connect with art" (a goal for which this exhibition seems particularly well suited). While everyone on our staff plays a part in our presentation of exhibitions, we extend particular thanks to Richard Feaster, registrar; Tabitha Griffith Loyal, exhibitions coordinator; and Denise Gallagher, project manager. Their diligence made the organization of the exhibition and publication a pleasure.

As chief curator, Mark Scala is often called on to facilitate projects from the broad range of exhibitions presented to fulfill the Frist Center's mission. We are pleased and grateful that he remains steadfastly disciplined in his own scholarship. Two previous exhibitions, *Fragile Species* and *Paint Made Flesh*, set the stage for the exhibition and publication *Fairy Tales, Monsters, and the Genetic Imagination*. Scala, once again, has made insightful connections and illuminating observations that enrich the museum-going experience.

And finally, we thank the fabulists whose artistic inventions call forth the magical, grotesque, and contradictory forces that lie within us all. Subverting the illusion of a coherent world with sometimes wicked delight, the artists in this exhibition are radical agents whose role is to break down boundaries between the real, the possible, and the imagined.

Susan H. Edwards, PhD
Executive Director and CEO
Frist Center for the Visual Arts

ARTISTS *in the* EXHIBITION

David Altmejd

Suzanne Anker

Aziz + Cucher

Ashley Bickerton

Meghan Boody

Chapman Brothers (Jake
 and Dinos Chapman)

Kate Clark

Marcel Dzama

Inka Essenhigh

Andre Ethier

Trenton Doyle Hancock

Mark Hosford

Walter Martin and Paloma Muñoz

Motohiko Odani

Patricia Piccinini

Paula Rego

Tom Sachs

Allison Schulnik

Cindy Sherman

Yinka Shonibare, MBE

Kiki Smith

Amy Stein

Janaina Tschäpe

Charlie White

Saya Woolfalk (in collaboration
 with Rachel Lears)

Lenders to the EXHIBITION

Andrea Rosen Gallery

Batterman-Greenberg Collection

Susan and Edward Bralower

Brian Clamp Gallery

Broad Art Foundation

Cindy Chupak

Penny Clive

David Zwirner Gallery, New York

Louise Déry

Brian Donnelly

Gallery of the University of Quebec, Montreal

Stuart S. Ginsberg

James P. Gray II

Harn Museum of Art, University of Florida

Heather and Tony Podesta Collection

Stéphane Janssen

Jeanne and Michael Klein

Jennifer Mallin

Joel and Sherry Mallin

Marlborough Graphics, New York

Montreal Museum of Fine Arts

Museum of Modern Art, New York

P.P.O.W. Gallery, New York

Pace Gallery

Private Collection, North Salem, New York

Rick Wester Fine Art

Salomon Contemporary

Herbert and Lenore Schorr

Barbara Shuster

Sikkema Jenkins Gallery

Skarstedt Gallery, New York

Sperone Westwater Gallery, New York

Marc and Livia Straus

303 Gallery, New York

Yamamoto Gendai Gallery, Tokyo

Fairy Tales, Monsters, and the Genetic Imagination

Mark W. Scala

This exhibition includes representations of creatures and stories that blur the boundaries between human and animal as a way of expressing the fluid nature of identity. In fusing unlike anatomical parts or behavioral traits, these works call to mind sources as diverse as folklore and tales of horror, science fiction regarding the life-altering consequences of technology gone wild, and, in real life, the expanding possibilities of biological engineering. Dissolving distinctions between human and animal, between reality and artifice, and between superstition, spirituality, and science, the art in the exhibition taps an imaginative flow that predates written language and will likely carry us into the future.

For the most part, these fantasies employ anthropomorphism (the projection of human traits onto animals) and its flip side, zoomorphism (the attribution of animal characteristics to people). As examples of the "animalizing imagination," they echo mythology and folklore in which human limitations are expanded by incorporating nonhuman anatomies or attributes, as seen in ancient times in mermaids, centaurs, vampires, and werewolves, and more recently in such characters as Spider-Man.[1] Moving from prerational belief systems and rituals to postrational speculation,

the animalizing imagination is given further meaning in the potential of transgenics, the actual moving of genes across species.

The Western belief in human exceptionalism has long caused the animalizing imagination to be pushed to the margins of serious discourse. For different reasons, dominant veins of theology and science have placed people separate from and above animals, while rejecting fantasy and folklore as expressions of ignorance or childishness. This human-centered hierarchy allows us to study animals dispassionately, to hunt, farm, tame, dissect, and eat them with no qualms. Yet it skirts the inescapable truths that, on the one hand, many people feel spiritually, genetically, or emotionally linked to animals, finding in them mirrors of humanity—"people in disguise"—and that, on the other hand, animals and humans have a surprising genomic kinship, which will become recognized as being even more intertwined as science conceives new variations of life based on combinations from existing genetic threads.[2]

While the emotional connection of the human to the animal is universal, it is in special evidence among young children, appearing in the popularity of pets, cartoons, teddy bears, and, of course, fairy

tales. Throughout this exhibition, children are shown as both actors and audiences. In Amy Stein's reenactments of reported animal sightings in rural and suburban Pennsylvania (pls. 1–2), girls who are likely the same age as Little Red Riding Hood and Alice in Wonderland—that is, around ten or twelve, edging toward puberty—gaze with fear and longing at such predators as a bear and a coyote, who gaze intently back with what we guess may be expressions of hunger, fascination, or curiosity. While reflecting the increasing numbers of wild animals that prowl our streets and alleys in search of food, Stein's staged encounters also elicit primal emotions. They remind us of our ancestral obsession with suppressing children's natural inclination to go "where the wild things are," in order to protect them from being eaten, molested, or carried away, or, in the context of self-realization, to keep them from confronting and absorbing the wildness in themselves and the world.[3]

Fairy Tales

The impulse to use animal metaphors to shield children from nature and their own wildness hearkens back at least to the seventeenth century. In his 1697 book *Histoires ou Contes du temps passé*, Charles Perrault adapted traditional stories such as "Little Red Riding Hood," "Cinderella," and "Sleeping Beauty" into lessons in morality and conformity disguised as the sugar pill of fancy. He wrote, "Is it not praiseworthy of fathers and mothers when their children are still not capable of appreciating solid truths stripped of all ornaments to make them love these truths, and, as it were, to make them swallow them by enveloping them in charming narratives which correspond to the weakness of their age?"[4]

Perrault, and later the Brothers Grimm and Walt Disney, promoted the idea that desirable traits—honesty, humility, thrift, cleverness—enable the story's heroes to overcome adversity: killing monsters, cooking witches, eviscerating wolfish men, outfoxing trolls and tricksters. But in addition to values that

we still consider to be positive, traditional fairy tales often reinforce beliefs in social hierarchies that are now discredited, such as male superiority and the natural goodness of the ruling class (especially princes and princesses). The violent resolutions of many fairy tales, when even the mildest of villains might suffer an extreme consequence, as in one of the Grimm versions of Cinderella, in which her mean stepsisters' eyes are pecked out by doves, underscore a view of the world as extreme, retributive, and unforgiving.[5]

In this exhibition, Walter Martin and Paloma Muñoz, Tom Sachs, Marcel Dzama, Paula Rego, and Kiki Smith explore these contradictions, often addressing such themes as sexuality, violence, and death, but in a way that removes them from the palpable here and now to a place that, like Perrault's tales, is safely metaphorical. The subject can be charming, as in Martin and Muñoz's luminous snow globe showing Humpty Dumpty about to fall and shatter into a hundred pieces (pl. 16). And it can be raw; Sachs's pyrographic painting *Hours of Devotion* (2008; pl. 12) reprises a nineteenth-century illustration in which the medieval anticlerical renegade Reynard the Fox brutally beats a pious rabbit with a bishop's scepter.[6] It appears in Dzama's depiction of malevolent Pinocchios in *La verdad está muerta / Room Full of Liars* (2007; pl. 13), and again in Smith's and Rego's deconstructions of frightening fairy tales and nursery rhymes, which strip away the gloss of sweetness that enables the listener to swallow such horrors as children being frightened by giant spiders, cock robins being murdered, and mouse tails being cut off (pls. 9–11).

The literary lineage of these artists extends back to the unknown origins of vernacular fairy tales, but their artistic ancestry dates to the nineteenth century, when romantic and symbolist artists and poets were drawn to mysticism and the occult, and to gothic fantasies of deadly seductresses, tormented heroes, and supernatural beings. They thrilled in giving fantastic form to subliminal elements, particularly of a sexual nature, that were thought to be repressed in the human psyche. It is hardly surprising that Perrault's stories had a new audience when they were repub-

lished in 1862 with illustrations by the artist Gustave Doré, with one renowned image showing the wolf in bed with Red (fig. 1), whose alarm seems mixed with curiosity and perhaps even a desire to get to know this intriguing creature better, like the girls in Stein's photographs.

While the belief that fantasy is a window onto our hidden urges, desires, and fears appears in Victorian literature—for example, *Alice in Wonderland* and *Peter Pan*, reimagined in this exhibition by Smith and Rego, respectively—it fully flowers in twentieth-century surrealism, with its debt to Freud and his notions of the unconscious as a driver of behavior. The noted child psychologist Bruno Bettelheim articulated a belief that is thoroughly woven into modern theories of the irrational when he wrote that "the child's unconscious processes can become clarified for him only through images which speak directly to his unconscious. The images evoked by fairy tales do this."[7]

Today, much of the discourse surrounding revelatory transformation centers on hybridity. In biology this refers to the offspring of parents with different genetic traits, but it has also come to mean any construction of differing parts or types, generally with the implication that the new form is an adaptation, natural or artificial, designed to respond to new circumstances, like the hybrid car. Artists in *Fairy Tales, Monsters, and the Genetic Imagination* have invented their own hybrids to explore the aesthetic and ethical possibilities arising from the mixed composition of species. "Who are we?" asks anthropologist Ian Tattersall. He describes *Homo sapiens* as "generous, selfish; gullible, shrewd; aggressive, retiring; smart, dumb; kind, cruel; shy, assertive."[8] Since we are already a complex of oppositions, some considered human, others nonhuman or inhumane, it makes perfect sense that we have devised an aggregate imagery to embody our own contradictory selves and self-perceptions.

If our inner beings are combinations of reason and instinct, traits we often think of as distinguishing human from animal, then fairy tales and other fantastic representations can close gaps within ourselves, and

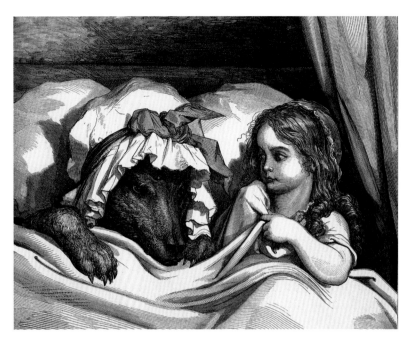

Figure 1. Gustave Doré, *Little Red Riding Hood*, 1862. "She could not help noticing how strangely her grandmother seemed to be altered." From *Fairy Tales Told Again*, illustrated by Gustave Doré (London: Cassell, Petter, and Galpin, 1872).

between us and the world. Meghan Boody, Trenton Doyle Hancock, and Mark Hosford use the syntax of the fairy tale to create psychosocial allegories of passage between the inner and outer realms. Boody's illustrated narrative series *Psyche and Smut* (2000; pls. 23–28) is, in her words, "a tale of psychic metamorphosis. It follows the relationship of Psyche, a polite, pinafored little girl and her deviant twin sister, Smut. Adopting the twins as agents of duality, the series functions like a Lacanian primer—a step-by-step slide show of how to achieve balance through the reconciliation of opposites."[9]

Hancock has similarly created an imaginary world in which "each character [is] a separate part of me. I can separate one aspect of my being out and then put it in front of me and then look at it. And it's kind of like all of these things are inside me at once, battling each other."[10] For example, in *Vegans Do Their Dirtiest Work* (2002; pl. 45), one of a series of works dedicated to an imagined epic conflict, Hancock conveys contradictions within himself and in society by illustrating a

war between the Mounds, overweight creatures who arose from a field of flowers after being generated through an ape-man's masturbation, and the Vegans, evil creatures who wish to destroy the Mounds. The scenario has its roots in the lessons of good versus evil contained in his childhood understanding of Christian morality, as well as the narrative clarity of superhero comics. There is a personal note as well; the ever-shrinking Vegans were meant to evoke certain actual vegans Hancock knows, a wry indictment of health-food devotees as being ideologically severe and moralizing, in contrast to the more liberated and hedonistic Mounds.

A popular theme in books and movies is that of children, sometimes sickly, sometimes without siblings or friends, who combat their loneliness either by imagining they are surrounded by magical occurrences or by translating life's mysteries into visions of the fearsomeness and threat beyond the wall, under the bed, or on the edge of consciousness. Hosford's videos, *Haunting 3* and *4* (2008–2009; pls. 29–30), show slumping, affectless children and creepily animated toys occupying claustrophobic rooms. Strange transformations occur all around; ghosts and dead bodies appear and then fade away; a spotlight swings like a pendulum, with time marked by the drip-drip-drip of blood into a pan; a girl is transformed into buzzing flies and then back again. These are all signals of a constant shuttling between death and life, normality and weirdness. Unlike a fairy tale, however, these videos have no beginning or end; they constantly loop, floating in time like recurring memories.

Monsters

Animals or animal-like beings in fairy tales and nursery rhymes often have human traits, in terms of either behavior, speech, or appearance. They are not all monsters, yet the word "monster" does often suggest an unnatural combination of species.[11] Monsters have frightening physical features and dangerous impulses, expressed as revenge, superhuman cunning,

uncontrollable hunger (especially for people), and rage. In cultures around the world, these inhuman or part-human brutes were invented to maintain psychological or social boundaries and threaten any who violated them with death and, frequently, being eaten. Monsters are often larger than people (so their prey can fit easily into the mouth) and have characteristics of animal predators—hairiness or scales, large mouths, and pointed teeth. They are also ugly, because beauty is, at least in Western traditions since Plato, associated with goodness.[12]

Such traits evoke the concept of *terribilità*, the sublime horror at beings and forces beyond comprehension. But as Marina Warner points out, monstrosity also may be accompanied by a sense of *capriccio*, a caprice or fancy that triggers mocking laughter.[13] This duality is seen in Andre Ethier's untitled painting (pl. 39) showing a bulging-eyed, sharp-fanged, hairy apparition, which appears as a mischievous caricature of that which is fearful, like the monsters in Maurice Sendak's children's book *Where the Wild Things Are* (1963).

Despite being partly comic, demonic grotesques like Ethier's are invariably associated with evil. They are "more comfortable in hell than heaven," in the words of Geoffrey Galt Harpham, descending from a long line of bizarrely formulated beings, from the three-headed dog Cerberus (protector of Hades) to the cavorting creatures in Hieronymus Bosch's *Garden of Earthly Delights*, which express the vices—gluttony, lust, greed—that can consign you to the nether region.[14] The surgeon Ambroise Paré's late sixteenth-century book *On Monsters and Marvels* argued that deformations in the body were either genetic anomalies or consequences of sinfulness, or both.[15] Some two centuries later, Goya's satirical etchings *Los caprichos* showed asses' heads on human bodies, human faces on chickens' bodies, and similar grotesque pairings to show the darkly irrational side of humanity. In his most famous etching, *The Sleep of Reason Produces Monsters* (fig. 2b), demons in the form of bats and owls hover ominously over an image of a sleeping man. This was created in 1799, a time when reason

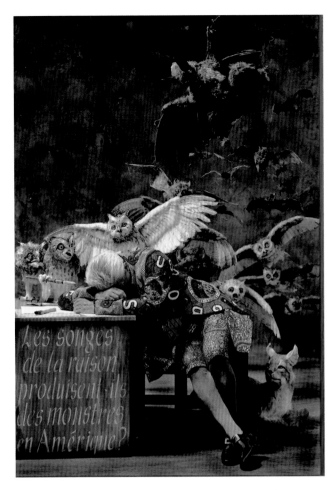

Figure 2a. Yinka Shonibare, MBE, *The Sleep of Reason Produces Monsters (America)*, 2008 (pl. 31).

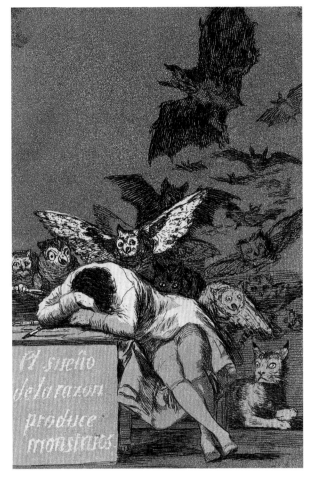

Figure 2b. Francisco José de Goya y Lucientes, *The Sleep of Reason Produces Monsters*, 1799. Etching and aquatint, 8 ⅜ x 5 ¹⁵⁄₁₆ in. Los Angeles County Museum of Art, Los Angeles. Paul Rodman Mabury Trust Fund (63.11.43).

seemed to be under assault by the hellish forces of fear, corruption, and degradation (a time, that is, like any other). The work was adapted by Yinka Shonibare in his *The Sleep of Reason Produces Monsters (America)* (2008; fig. 2a, pl. 31), one of four photographs that also refer to Africa, Asia, and Europe. For Shonibare, who often comments on the contradictions inherent in colonialism, the work reflects the monsters unleashed under the aegis of the Enlightenment: racism, slavery, war, economic exploitation, and other blights of Western history.

Inka Essenhigh's *Brush with Death* (2004; pl. 37) evokes another of Goya's series, *The Disasters of War*. Here the monster returns as an embodiment of a contemporary horror, the war in Iraq. While typically Essenhigh creates fantastic creatures floating through dreamlike settings, as in *Green Goddess I* (2009; pl. 36), here she renders war as a snarling demon from below, who reaches for an elusive creature dancing aloft in the night sky. This is at once a universal allusion to war's insanity and a deeply personal expression of the fear Essenhigh felt when her husband, the artist Steve Mumford, went to Iraq to embed himself with American troops and capture their stories in documentary drawings and paintings. Essenhigh showed Mumford as a joyful sprite who flirts with the dangerous forces of irrationality, as if war were a game of tag or hide-and-go-seek, and the task of the artist-

Figure 3. Max Ernst, *Une semaine de bonté ou Les sept éléments capitaux*, vol. 4, from a five-volume serial novel by the artist, 1934. Publisher: Éditions Jeanne Bucher, Paris. Printer: Georges Duval, Paris. Edition: 816. The Museum of Modern Art, New York. Louis E. Stern Collection.

insectlike mommy-monster in *Alien* (1979) reflect what Creed calls "historical notions of abjection" ascribed to women: "Following an ancient pattern, they mirror one or more aspects of a spectrum of religious 'abominations': sexual immorality and perversion; corporeal alteration, decay and death; human sacrifice; murder; the corpse; bodily wastes; the feminine body; and incest."[16] This mixed bag of horrors (and things that are not horrible, like the female body) is perhaps most manifest in the idea of the witch—the female sorceress of lore who was herself the victim of real-world horrors such as the Inquisition and the Salem witch trials. Cindy Sherman, concerning herself with the effect of various symbolic representations of women throughout history, evokes the archetypal she-hag in *Untitled #191* (1989; pl. 35). With her long hair, bloodshot come-hither eye, and exposed breasts offering gross parodies of sexual and other appetites, this horrific creature calls to mind descriptions of Grendel's mother in *Beowulf*, which have been translated as "monstrous hell bride," "Monster woman," "ugly troll-lady," and "monstrous hag."[17] The creature, of course, is Sherman, who has made herself up to look this way. The monster may not actually exist, but the emotion she inspires is palpable, even if it is a product of our minds rather than external conditions—the fear itself is far more tangible than its source.

Monstrosity can also have a liberating dimension, as in works by Max Ernst and other surrealists who show grotesque hybrids as rejections of social and sexual constraint, reason, and tradition. The monstrous bird-headed people in Ernst's book *Une semaine de bonté* (*A Week of Kindness*; 1934) destroy the boundaries between the real and the imagined, desire and repulsion, murder and love (fig. 3). A similar transgressive agency is found in the "Exquisite Corpse" game devised by the surrealist André Breton around 1925 (fig. 4a). This collaborative activity involved folding a piece of paper into sections, then drawing on one of the sections and refolding it so only a small amount of the drawing was visible. The paper would then go to the next player, who would expand on the fragment of visible information to create his or her extension of the drawing. This would

correspondent were to live through it all, dodging and dancing beyond the grasp of monstrous death.

Just as colonialism and war are monsters too vast and voracious to easily absorb through rational means, the historical fault lines of gender relations are often approached through allegory and allusion, engaging what Barbara Creed and others have termed "the monstrous feminine." Creatures ranging from Medusa and the Sirens to the Wicked Witch of the West to the

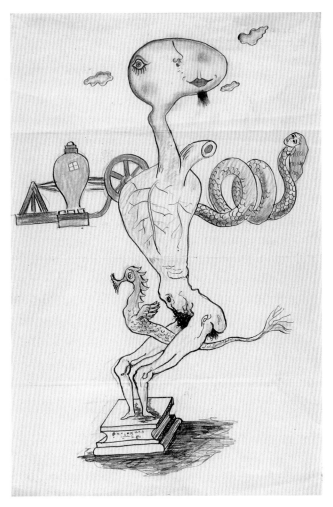

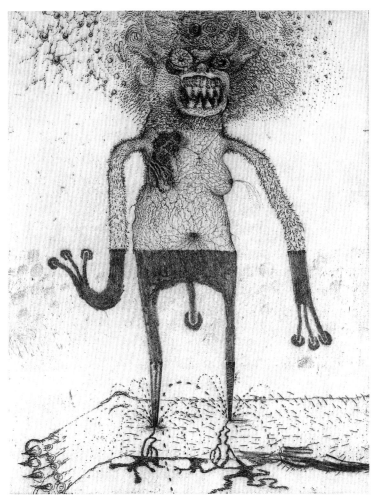

Figure 4a. Man Ray, André Breton, Yves Tanguy, Max Morise, *Exquisite Corpse*, 1928. Pen, brown ink, graphite and smudging, and colored crayons on cream wove paper, 12 ¼ x 7 ⁹⁄₁₀ in. Art Institute of Chicago. Lindy and Edwin Bergman Collection, 106.1991.

Figure 4b. Jake Chapman and Dinos Chapman, *Untitled from the portfolio "Exquisite Corpse,"* 2000 (pl. 40).

continue through three or four players, most of whom drew fragments of human, plant, or animal anatomy, with notable emphasis on breasts, vaginas, and hair. The end result was an impossible hybrid, revealing the ambiguity, dissolution of sexual boundaries, and embrace of possibilities that are contained within the human mind. In this exhibition, the Chapman brothers, Dinos and Jake, have revisited the game, providing their own inventions as indicators of the complexity and contradictions of twenty-first-century reality (2000; fig. 4b, pls. 40–43).

The surrealists recognized the mind-altering effects of imaginative play, in which random associa-

tions, magical transformations from one material to another, even the frisson aroused by simulated death can be agents in breaking down barriers between the internal and external worlds. These metamorphic strategies continue to lead to the marvelous, as with David Altmejd's *Untitled (Man's Hard Idea Comes Out of His Head)* (2007; pl. 33), in which a bust of a bird's head is clothed in a fragment of a business suit, shirt, and tie. Instead of a standard comb, this roosterlike creature sports a florid embellishment that seems to have sprung writhing from within its beak to grow over its forehead in poisonous profusion. Evoking the bird-headed people in Ernst's *Une semaine de bonté,*

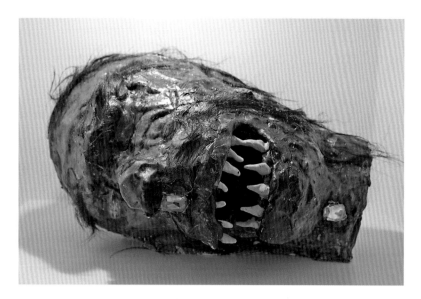

Figure 5. David Altmejd, *Werewolf 1* (*Loup-garou 1*), 2000 (pl. 32, detail).

the creature is fearsome, as he glares out with the calculating eye of a predator measuring the distance to his prey (an apt metaphor for the stereotype of the rapacious businessman). But as with Ernst's creations, the bird-headed figure seems more than an unnameable threat with evil intent. He is a hallucination that, as indifferent as a chicken, will become or enact what our secret minds most fear or desire.

If there is any sense of danger arising from the bird-headed man, it is because he signals an open rupture in our biological and psychological understandings of the world; we do not believe that he will eat us. The fear associated with the creature shown in Altmejd's *Werewolf 1* (*Loup-garou 1*) (2000; fig. 5, pl. 32) is more atavistic. Named for the monster that has long signified the capacity of men to move surreptitiously between the village and the nocturnal forest (the locus of unreason ruled by animal lust and appetite), the work has as its defining element the decaying head of a werewolf. The head has been placed on its side, visible in a window in a box, a construction that is reminiscent of one of Donald Judd's minimalist sculptures but that also suggests a display case in a natural history museum.

The use of this architectural element—which conflates modernism's ideology of stylistic purifica-

tion and the scientific impulse to collect, study, and display specimens—appears to argue for the victory of intellect over emotion. Yet the work does not herald the end of irrationality. If a werewolf could exist in a viewing case, it could exist outside; where there is one, there may be others—it is a sign of an extant threat. If the parody of scientific presentation is meant to minimize the beast's mystery by encouraging clinical observation, that same observation yields a sense of magic—embedded in the head are gemstones, suggesting that as he decays, beautiful new forms are generated. The transformation from organic grotesquerie to crystalline beauty recurs in the inverted icicles that seem to rise up from the illuminated top of the box, which we may read as the frozen breath of a departed spirit that metaphorically brings the beast from his crypt into our space. Joining reason to nightmare, death to life, human to animal, *The Werewolf*—itself exquisite, and itself a corpse—offers a metaphor for psychic ruptures through which the new growth envisioned by the surrealists may occur.

Surrealism's conflation of the external and internal also occurs in Allison Schulnik's video *Forest* (2009; pl. 69), in which bizarre figures fashioned in clay are superimposed onto real footage from nature. In a Claymation narrative that defies linear understanding, multicolored monsters yearn for each other from across a stream; wishing to get nearer, one steps into the stream and is transformed into a twitching array of rich colors, clay now become liquid. Other absorptions occur—small green monsters are eaten by a lizardlike creature; a spacecraft lowers itself onto the scene and somehow draws the main character up into it.

Inspiring a contradictory mixture of pleasure, loss, and transcendence, Schulnik writes that she is drawn both to the "forlorn reject" and the "brilliant and foolish genius outcast."[18] With similar ambivalence, Altmejd's werewolf at once attracts and repels. In this, both artists evoke the story of Frankenstein, who instilled in his creation a cultured sensibility that in a less horrid being would be considered charming. As the archetypal cautionary tale about the unpredictable consequence of collaging body parts, Mary Shelley's

masterpiece sends the message: don't play at being God the creator, but if you do, embrace your creations, no matter how repulsive. Illustrating that there are sometimes good reasons for bad behavior, monsters like Frankenstein's seek revenge because they are outcasts, or they try to protect themselves from those who would kill them out of fear, ignorance, or, in some cases, the desire to manipulate public opinion for other ends.

Sometimes, monsters run amok not simply out of hurt feelings but also in revenge for the careless destruction of nature through scientific, military, or industrial means (Godzilla as a reflection of the nuclear attacks on Japan comes to mind) (fig. 6). This is the implication of Ashley Bickerton's *Snake-Head Painting* (2008; pl. 47), a human-headed, phallic green sea creature who rears up in a field of flowers and multicolored paint blobs that resemble the rainbow hues of an oil slick. Its facial expression conveys the distinctly human feelings of anger or accusation. The image is from a body of work produced after the artist moved from the United States to Bali, where he still lives. In these tropical dystopias, grotesque, garishly colored people indulge in every behavioral excess imaginable, as if lampooning Paul Gauguin's dream of the noble (and sexually available) savage with a comic-book story line of obscene self-gratification. Bickerton's cast of characters includes the snake-heads, vengeful hybrids spawned in tropical ecosystems, which have been threatened by the detritus of civilization as it makes its way across the planet, often on currents that take it to the southern oceans. As often happens in science-fiction movies featuring new breeds of monsters, *Snake-Head Painting* leads us to wonder whether the monster came into existence through some human failure or hubris, and what havoc it might wreak on us (that is to say, what havoc are we wreaking on ourselves via the proxy of the monster?). Because this creature is part human, such questions can be generalized to reflect on humanity itself, as in the title of one of Gauguin's paintings—Where do we come from? What are we? Where are we going? For *New York Times* art critic Holland Cotter, the answers

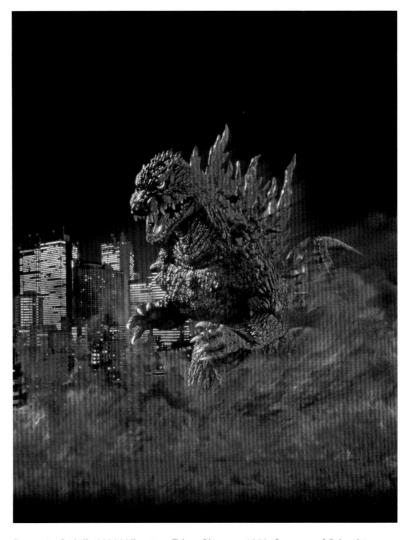

Figure 6. *Godzilla 2000 Millennium*. Takao Okawara, 1999. Courtesy of Columbia Pictures.

are as simple as they are bleak: "This is what we are. We're going nowhere. This is the end of the line."[19]

The Genetic Imagination

If a monstrous mutation in science fiction is a one-off, all we have to do for a happy ending is destroy it. But the genre often poses scenarios in which the monster's potential for breeding spells possible doom for humanity. Frankenstein's monster will call off his threat to murder the doctor's fiancée if the doctor makes for him a mate, similarly gifted with supernatural strength

and intellect. Afraid of the horrors he might unleash if the two managed to procreate, Frankenstein refuses, sacrificing his happiness for the future of the world. This Pandora's box theme recurs in stories such as *Jurassic Park* (1993) and the long string of *Godzilla* movies, tapping into our greatest fears about genetic engineering.

It may seem odd to link old-fashioned fairy tales and monsters to science. Yet since the 1980s, a spectrum of fantasies in both art and science fiction has been inspired by the threat and promise contained in genetic engineering. The imaginative flowering triggered by the potential collaging of genetic materials began not with artists but with scientists themselves, as reported by Philip R. Reilly in his introduction to Suzanne Anker and Dorothy Nelkin's *The Molecular Gaze: Art in the Genetic Age*:

I can still feel the electricity in the air in a lecture room in Houston when in the mid 1970s a standing-room-only crowd of scientists gathered to hear Paul Berg, himself a Nobel laureate, lecture on the use of restriction enzymes to cut and paste DNA, in essence to reengineer living things. That day the talk was of moving genes around in viruses; today it is of moving human genes into goats; tomorrow it will be of enhancing the human genome. No wonder the artists have taken notice![20]

In the same book, Anker and Nelkin discuss a wide range of artistic responses to such subjects as artificial selection, hybridization, and mutagenesis. While the artists they cover may worry about ethical implications and negative biological consequences, this is often offset by a profound excitement about the spiraling expansion of media and meanings that are offered by involvement in the "bio-art" arena. This trend, itself a hybrid of disciplines, gives new meaning to the modernist ideal of art becoming more completely entwined with life—not by becoming more like the matter of the everyday, but by using actual living materials as its medium.

A growing number of artists are becoming involved with bio-art, which artist Eduardo Kac describes as a type of art that "manipulates the processes of life . . . [through] (1) the coaching of bio materials into specific inert shapes or behaviors; (2) the unusual or subversive use of biotech tools and processes; and (3) the invention or transformation of living organisms with or without social or environmental integration."[21] That such innovations come from artists rather than scientists hardly allays concerns about the threat that new types of life may pose to existing ones. Yves Michaud, among others, has written of the responsibility that attends the creation of new organisms for aesthetic purposes. It is essential, he feels, for the bio-artist to consider whether his or her efforts are "correct, decent, and appropriate."[22]

This is a milder version of the admonition contained in science fiction that regards the uncontrolled manipulation of genetic materials and the collaging of human and machine as dangerous extensions of the Frankenstein myth. Such films as *Blade Runner* (1982) and *Gattaca* (1997) paint bleak pictures of a world in which humans born the old-fashioned way are at a disadvantage when pitted against the new superbeings. (It is generally supposed that such antagonisms will be the inevitable outcomes of the split between natural and manufactured species.) A scarier scenario still is offered in Vincenzo Natali's 2008 film *Splice*, in which two biotech engineers (who happen to be an adorably hip couple) create a humanlike test-tube baby-thing that spells horror and sexual mayhem before the movie ends.

Descended from monster literature, this genre of fiction brings us far closer to actual possibility than *Godzilla* ever could; Godzilla, after all, is a metaphor (I think). The artists in *Fairy Tales, Monsters, and the Genetic Imagination* are not bio-artists; they employ a fictive language of human-animal composition, which strongly evokes the folkloric and monstrous symbols of the past to reflect the psychological rather than biological consequences of genetic engineering.

For these artists, the creative potential of the new

developments is exhilarating, offering to take the interaction between art and science in heretofore unimaginable directions. They have designed their own chimeras to symbolize the hopes, dreams, and ethical questions that stem from genetic engineering, with its emphasis on becoming rather than being.[23]

The most salient metaphor that Aziz + Cucher (pls. 48–50), Janaina Tschäpe (pls. 60–67), and Saya Woolfalk (pls. 70–71) draw from DNA splicing is that of transmutation, the changing of one type of being into another, more complex one, creating not just human-animal and animal-animal hybrids but also human-plant and male-female. Their crossing of species and sexual boundaries offers an optimistic alternative to natural biology as a force shaping what life is to become. Curiously, each completes the circle with the past through archaizing imagery. Aziz + Cucher represent new life in the form of crude handheld artifacts that evoke an archaeologist's find, but sheathed in human skin and hair; Tschäpe, in her Polaroids, revisits the way that nineteenth-century fairy pictures aligned the supernatural little creatures with insect and plant life; and Woolfalk derives inspiration from the colorful masquerades of indigenous cultures, particularly in Brazil, where she has traveled often in the company of anthropologists.

If there is a cautionary note in this selection of works, it is struck by Patricia Piccinini, who warns not of a Pandora's box of unleashed genetic horrors, but of our own unpreparedness in dealing ethically and humanely with the results of our scientific adventurism. Piccinini's *Still Life with Stem Cells* (2002; pl. 55) shows a little girl who interacts with the weird blobs of genetic matter—stem cells, all with the potential of growing into different organisms—that surround her as if they are pets, toys, or soon-to-be playmates. Placing play and nurture over fear and rejection, Piccinini asks of our own modern creations the same questions haunting Frankenstein's monster and the children in Kazuo Ishiguro's novel *Never Let Me Go* (2005)—a poignant story of children who are cloned and harvested for body parts that has affected Piccinini deeply: Why were we made? Who will love us? What is our destiny? These are concerns, of course, that our genetically altered offspring would have in common with us. We can only ask God and not expect an answer; in the future, will we be able to answer our own creations as they move from fiction into reality?

Notes

1. The term "animalizing imagination" is used by Gaston Bachelard in *Lautréamont* (Dallas: Dallas Institute Publications, 1986), 27, and discussed by Alan Bleakley in *The Animalizing Imagination* (Basingstoke, UK: Palgrave Macmillan, 2000).

2. The wonderful phrase "people in disguise" comes from the title of an essay by the anthrozoologist James Serpell in *Thinking with Animals: New Perspectives on Anthropomorphism*, ed. Lorraine Daston and Gregg Mitman (New York: Columbia University Press, 2005), 121.

3. Jack Zipes compares this to tendencies in more archaic cultures to seek an awareness of what lies beyond civilization's enclosure, to "experience the wildness within themselves, their animal nature," abandoning themselves to what he calls their "second face." Zipes, *Fairy Tales and the Art of Subversion* (New York: Routledge, 2006), 45.

4. Charles Perrault, *Histoires ou Contes du temps passé* (1697), quoted in ibid., 33.

5. The Grimm Brothers example is noted in Max Lüthi, *The Fairytale as Artform and Portrait of Man* (Bloomington: Indiana University Press, 1984), 153.

6. The German folk poem "Reynke de vos" (Reynard the Fox) was published anonymously in 1498. Goethe translated it in 1794. Sachs's work replicates an image from the 1845 illustrated edition of Goethe.

7. Bruno Bettelheim, *The Uses of Enchantment* (New York: Random House, 1975; repr., New York: Vintage, 1989), 31.

8. Ian Tattersall, *Becoming Human: Evolution and Human Uniqueness* (Orlando: Harcourt Brace, 1998), 199.

9. Meghan Boody, "Artist Statements: Psyche and Smut, 2000," *lookingglasslabs.com/statementD.html*.

10. See extended interviews and video of Trenton Doyle Hancock on the Art 21 website, *www.pbs.org/art21/artists/hancock/index.html*.

11. David Gilmore writes, "The monster is never created out of nothing, but rather through a process of fragmentation and imaginative recombination in which elements are extracted from various forms in nature and then reassembled," in *Monsters: Evil Beings, Mythical Beasts, and All Manner of Imaginary Terrors* (Philadelphia: University of Pennsylvania, 2003), 21.

12. See Chapter 1 of *On Ugliness*, edited by Umberto Eco, for a quote about the dwarf Aesop's ugliness, described as having "a disgusting fat belly, bulging head, pug-nose, gibbous, swarthy, and short." It is perhaps surprising that someone whose appearance violates the harmonious ideals of classical society should use animal metaphors to talk about human behavior in that society, without bitterness or satire. Eco, *On Ugliness* (New York: Rizzoli, 2007), 30.

13. Marina Warner, *No Go the Bogeyman* (New York: Farrar, Straus, and Giroux, 1999), 247.

14. Geoffrey Galt Harpham, *On the Grotesque: Strategies of Contradiction in Art and Literature* (Princeton, NJ: Princeton University Press, 1982), 8.

15. Ambroise Paré, *On Monsters and Marvels* (1573; trans. 1840; repr., Chicago: University of Chicago, 1982).

16. Barbara Creed, *The Monstrous Feminine: Film, Feminism, Psychoanalysis* (London: Routledge, 1993), 9. Creed makes clear her debt to Julia Kristeva's groundbreaking psychoanalytic study *The Powers of Horror*, which explores the nature of the abject "as a means of separating out the human from the non-human and the fully constituted subject from the partially formed subject." Creed, *Monstrous Feminine*, 8.

17. In order of translations: Seamus Heaney, *Beowulf: A New Verse Translation* (New York: Norton, 2001); Howell D. Chickering, *Beowulf* (Garden City, NY: Anchor, 1989); Richard M. Trask, *Beowulf and Judith: Two Heroes* (Lanham, MD: University Press of America, 1998); Charles W. Kennedy, *Beowulf, the Oldest English Epic* (New York: Oxford University Press, 1940).

18. "Artist and Alumna Allison Schulnik Talks Hobo Clowns and Grizzly Bears," *24700: News from the California Institute of the Arts*, April 21, 2010, *i1.exhibit-e.com/markmoore/af819926. jpg*.

19. Holland Cotter, "Art in Review: Ashley Bickerton," *New York Times*, May 19, 2006.

20. Philip R. Reilly, "Divining DNA," in Suzanne Anker and Dorothy Nelkin, *The Molecular Gaze: Art in the Genetic Age* (Cold Spring Harbor, NY: Cold Spring Harbor Laboratory Press, 2004), xiii.

21. Eduardo Kac, "Introduction: Art That Looks You in the Eye: Hybrids, Clones, Mutants, Synthetics, and Transgenics," in *Signs of Life: Bio Art and Beyond*, ed. Kac (Cambridge, MA: MIT Press, 2007), 18.

22. Michaud further reminds us that the surrealists "defined the surrealist act as a person going down the street with a loaded revolver and emptying it on the first passerby," yet we do not look at "serial assassins or hideous criminals as surrealists." Yves Michaud, "Art and Biotechnoloy," in Kac, *Signs of Life*, 392–94.

23. Anker defines the chimera as a monster from Greek mythology, with a body of a goat, head of a lion, and tale of a serpent. It had the "capacity to transcend and ignore species boundaries, and so embodied dangerous spiritual and emotional qualities." By 1968, "chimera" had become a term in genetics, used to describe organisms that were made up of cells and tissues from two or more species conjoined from genetically distinct embryos. Anker and Nelkin, *The Molecular Gaze*, 92.

Fairy-Tale Collisions

Jack Zipes

It has become impossible for serious artists to accept the traditional "goodness" of fairy tales in a globalized world that appears to have gone haywire. Nevertheless, there are profound meanings in the classical fairy tales that have evolved from human conflicts of the past. These tales cannot speak to us, however, unless their underlying dramas are exposed and allowed to counter and collide with complex social realities. Collisions do not have to end in destruction. They are necessary to disrupt and confront clichés and bad habits. They are necessary to shake up the world and sharpen our gaze. In this regard, contemporary fairy-tale artworks, though often dystopian, still pulsate with utopian fervor.

From the nineteenth century through the 1960s, visual artists generally celebrated the opulent and extraordinary optimism of the fairy tale in diverse works: paintings, sculptures, illustrations, photographs, cartoons, and films. However, their felicitous visions have dramatically shifted in the past fifty years. No longer do contemporary artists interpret and portray fairy-tale realms as enchanting dream worlds that lure the eye to bask in an idyllic setting or divert the viewer from the ugliness of the everyday world. On the contrary, they have approached fairy-tale topics from a critical and skeptical perspective, intent on disturbing viewers and reminding them that the world is out of joint and that fairy tales offer no alternative to drab reality. Their subversive views of the fairy tale collide with traditional norms and conventional expectations of fairy-tale representations, and they collide with the false rosy images that the Disney corporation and other popularizing artists and publishers have disseminated for close to a hundred years.

Paradoxically, to save the essence of hope in the fairy tale, contemporary visual artists have divested it of beautiful heroes and princesses and cheerful scenes that delude viewers about the meaning of happiness, and at the same time they have endowed the fairy tale with a more profound meaning through the creation of dystopian, grotesque, macabre, and comic configurations. Their works collide with past fairy-tale conventions by engendering extraordinary imaginative narratives through images that compel viewers to question whether it is possible to lead a fairy-tale life in a rapidly changing world that appears to champion ugliness and brutality over beauty and kindness.

Fairy-tale collisions stem, in my opinion, from

the conflicts of the 1960s when the civil rights and antiwar movements, followed by a resurgence of feminism and educational and political reforms, led many young people to believe in the power of the imagination, revolutionary transformation, political justice, and utopian hope. Yet virtually none of the wishes and dreams of the 1960s generation have been fulfilled. Instead, we wallow in a world filled with conflict, false promises, corruption, and material greed. As a consequence of the deterioration of social, political, and cultural conditions, numerous artists have employed the fairy tale, not to encourage utopian urges but to pierce artificial illusions that make it difficult for people to comprehend what is happening to them. Ironically, these artists imply that viewers can come to terms with reality through fairy-tale images that are intended to disrupt anyone who encounters them. The encounter is a fortuitous collision that will make viewers stop and think about the meaning of fairy tales and happiness. The encounter is also an act of re-creation, for viewers are obliged to imagine their own reality and narratives while gazing at the image.

There are two major tendencies in fairy-tale re-creations and collisions that have struck my eye in the past few decades, and there may be more depending on how one views the different techniques and styles of the artists. The first tendency, what I call re-creating classical tales, concerns explicit references to well-known fairy tales such as "Cinderella," "Little Red Riding Hood," and "Snow White." Given the sexist disposition of most of these popular tales, the artists who use them explicitly as their subject matter tend to offer a startling critique with images that urge, perhaps even provoke, viewers to rethink what they know about the tales. The second tendency, what I call conflicted mosaics, consists of paintings, sculptures, and photographs that draw on an assortment of fairy-tale fragments to evoke a sense of wonder if not bafflement. The images are otherworldly, bizarre, and lush. They are not associated with any one particular fairy tale but are fairy tales unto themselves. Most do not evoke utopia or

promise happiness. They are simply concerned with otherness or estrangement.

Both these tendencies are widespread in Europe and North America, and it is impossible to summarize the hundreds if not thousands of visual fairy-tale works that were produced from 1970 to 2010, comprising painting, illustration, graphics, animation, design, digital images, photography, and so on. Therefore, I shall discuss the significance of the two tendencies in fairy-tale collisions with a focus on the artists in the present exhibition, *Fairy Tales, Monsters, and the Genetic Imagination*, and I shall also cite the works of some other unique artists (not represented in the exhibition) who have been experimenting with the fairy tale along the same lines. Here it is important to bear in mind the words of John McEwen, who has noted in England that 70 percent of the artists who have become professional since the mid-1980s are women: "Art lies beyond age, race, or sex but is nonetheless affected by them all. The worldwide rise of women artists is the greatest artistic revolution of this age."[1] In fact, in the particular case of fairy tales and other popular stories, the views of women artists and writers have clashed and continue to clash vividly with the mainstream production of these narratives: fairy tales are no longer what they seem to be and are no longer once upon a time. As collisions, they are part of our time.

Re-creating Classical Fairy Tales

In my opinion, the two most extraordinary contemporary artists who have totally revamped the manner in which viewers are to regard and interpret classical fairy tales and other popular stories are Paula Rego and Kiki Smith. Both dismantle literary and painterly norms and expectations with feminist humor and rage and cause spectators to rethink what they believe fairy tales mean and consider how they might re-create narratives in their own minds as Rego and Smith do. Or not—for there is also a dark side to the visions of Rego and Smith.

In 1985 Rego stated,

My favourite themes are power games and hierarchies. I always want to turn things on their heads, to upset the established order, to change heroines and idiots. If the story is "given" I take liberties with it to make it conform to my own experiences, and to be outrageous. At the same time as loving the stories I want to undermine them, like wanting to harm the person you love. Above all, though, I want to work with stories which emerge as I go along. It is something I have done in the past, and now I wish to do exactly that.[2]

Rego is indeed a storyteller-as-subversive-artist par excellence. Whether she depicts scenes based on Portuguese folk tales, nursery rhymes, classical fairy tales, or her own experiences and dreams, she delves into their grotesque and surreal aspects to grasp and exorcise oppressive and troubling elements related to experiences that most people do not want revealed or discussed. Deep-seated wounds are uncovered, many of which are buried in tales that are generally meant to soothe the anxious mind. They are colorfully resurrected and plastered in her works.

In 1989 she created the *Nursery Rhymes* series, published as a book with thirty-five images in etchings and aquatint that turn classical delightful verses for children into haunting scenes of cruelty, abuse, horror, and comedy. Although Rego had already revealed in her early surrealistic paintings how she would challenge the fluid, realistic, and traditional forms of narrative, these images were among the first she created to serve as counterpoints to known texts and were her very first experimental etchings.

In *Little Miss Muffett III*, *Who Killed Cock Robin I*, and *Three Blind Mice II* (pls. 11, 9–10), the funny nonsense of the rhymed verses are offset by Kafkaesque images of insects and animals filled with dread. There is very little to laugh about as the tentacles of a gigantic half-human spider threaten Little Miss Muffett. The farmer's wife seems vicious and sadistic with her raised knife, and the large blind mice are *not* a sight to see as they helplessly dance before her. The spider, fly, and various birds who seek to bury Cock Robin are more menacing and absurd than caring, and the sparrow appears to be proud of having killed the robin.

Rego is a partisan artist. She takes sides—particularly those of children and women—as she seeks to uncover the darkness of stories that we read and tell ourselves. But she does not depict her subjects as helpless victims. Rather they are enmeshed in distorted social relations. In 1992 she followed *Nursery Rhymes* with a probing exploration of J. M. Barrie's *Peter Pan* that turns the sentimental fairy-tale play into a fierce survival-of-the-fittest drama. Rego produced approximately twenty-five etchings and aquatints, from which fifteen were chosen for the publication of the Folio Society's book *Peter Pan, or The Boy Who Would Not Grow Up*, introduced by Andrew Birkin. Whereas Barrie made it clear in his play that the adventures in Neverland were all make-believe, Rego's illustrations suggest otherwise. They are filled with brutal images of a mermaid drowning Wendy, Tiger Lily mercilessly tied up on a rock, cannibalistic pirates carrying off the naked Lost Boys, and Captain Hook dueling a strange-looking Peter who appears as a diminutive older man in a typical dueling outfit while the Lost Boys sit anxiously bound together in front of an alligator swallowing a dog.

Rego's largest major image in the collection, *The Never Land* (pl. 7), depicts a small shadow cutout of Peter in the upper left and a full-grown Wendy in her nightgown descending through the air toward an island. It seems that they are landing in death's realm, for Hook is depicted with his face as the skull of death. Wendy is landing in the water next to the skull of an ox. Other animals including the alligator and a hippopotamus are swimming in the water alongside Lost Boys and Indians in canoes. Clearly, Rego's idea of life in Neverland collides with Barrie's concept. Perhaps one could say that she exposes everything Barrie was afraid to write, for her images are brooding scenes from the play that evoke sadistic pleasure and disturbing urges. Most of the characters, who are never portrayed in an identical manner, are trapped,

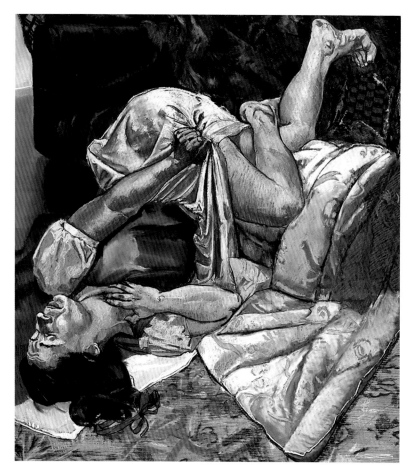

Figure 7. Paula Rego, *Snow White Swallows the Poisoned Apple*, 1995. Pastel on paper, mounted on aluminum, 70 x 59 in. Courtesy of Marlborough Fine Art, London Ltd.

fighting, or mocked. Rego's re-creation of *Peter Pan* is a profound questioning of Barrie's own creation and an appropriation that calls for a new retelling.

This call for retelling is the salient feature of Rego's superb re-creations of "Snow White" and "Little Red Riding Hood." The works in these series are not in the present exhibition but are important to note because they show how strong her disposition for reconceptualizing fairy tales is. In 1995, she rendered the Disney image of Snow White totally banal with several lurid pastel images of a domesticated Snow White who is brawny, solemn, and mute. In *Snow White Swallows the Poisoned Apple* (fig. 7), Rego depicts the violent death of Snow White in the traditional Disney garb. However, this Snow White appears to have been

violated on a disheveled couch. She clutches her skirts as if she has lost not only her life but her virginity. This Snow White has not survived the ordeal she has been made to suffer, whether because of the jealousy of her stepmother or her own naïveté.

In contrast to the *Snow White* series, Rego's *Little Red Riding Hood* series of 2003 represents a very optimistic view of a mother and grandmother protecting a girl from male predators. All her retellings of classical fairy tales question how women and children are raised and treated and project borderline images of loving care and brutality, joy in life and sadistic punishment. Rego bores into the troubled psyches of the characters of her tales, and she is not afraid to spill blood and guts in her re-creations.

This is also true of Kiki Smith, another subversive artist and storyteller who has often used fairy-tale motifs in her works. When I think of her artistic re-creations, I think of blood, the body, rupture, and movement. Nothing ever stays still or fits exactly into our frame of reference in her artworks. Smith tells all sorts of stories through her art, and they keep changing as the modalities of her art change.

In the case of the fairy tale, her work is in keeping with the second phase of feminist and postmodern writers and illustrators of fairy tales that became productive in the 1980s, especially Angela Carter, Tanith Lee, and Robert Coover, whose works are disconcerting and unsettle our views and understanding of traditional tales. Like these writers, Smith focuses on bodies and blood, fluidity and flexibility, surprising formations through rearrangement of object relations, and the provocation of new associations within spectators, who might then be stimulated to form their own stories. Take the tale of "Little Red Riding Hood," for example. How is a viewer to read "Little Red Riding Hood" after viewing Kiki Smith's installation *Telling Tales* (2001)? Are the sculptures, color photographs, paintings, drawings, stop-animation, and lithographs that make up the installation related? That is, do they tell one carefully conceived and neatly structured story? I would argue no, with one proviso.

Since they have been created by the same artist, who
has been fascinated by the story of "Little Red Riding
Hood" and other fairy tales such as "Sleeping Beauty"
and "Rumpelstiltskin" for the past twenty years, there
are bound to be connections between the works. But
I would argue that each artwork tells a different story,
and they all tell the story of "Little Red Riding Hood"
anew.

It is well known that Little Red Riding Hood in
the two classical versions by Charles Perrault and the
Brothers Grimm is not a heroine. She is more of a
wimp. Either she stupidly agrees to an assignation with
the hungry wolf and is complicit in her own rape/vio-
lation and death (Perrault), or she needs the help of a
hunter to free her from the wolf's belly (Grimm). This
is not Smith's Red Riding Hood at all, and like Carter
and the best fairy-tale writers, Smith provides us with
multiple versions of Red Riding Hood, who is not sim-
ply heroic but fleshed out in different contexts. In her
stunning four-foot sculpture *Daughter* (1999; fig. 8),
co-created with Margaret Dewys, made out of nepal
paper, bubble wrap, methyl cellulose, hair, fabric, and
glass, we are presented with a young girl wearing a
red wool cape and hood that contrast with her white
dress. Her face and head are covered by wild strands of
hair, perhaps the fur of the wolf. Her mouth is slightly
open and her hazel eyes glance upward as if she were
somewhat desolate, perhaps lost. She is transfixed, not
moving. Who is she? A mutant? The daughter of Red
Riding Hood and the wolf? Was Red Riding Hood not
harmed?

The wolves are rarely vicious or dangerous in
Smith's images. In the glass painting *Gang of Girls
and Pack of Wolves* (1999), the bronze sculpture *Wolf*
(2000), and the lithograph series *Companions* (2001),
the wolves are noble, sturdy, larger than life, but they
are more friendly and protective than threatening.
They remind me of the wolf in Angela Carter's story
"The Company of Wolves," which ends with the female
protagonist holding the wolf in her arms after having
apparently tamed him. Smith's work raises a number
of questions. What is the relationship of the wolves to

Figure 8. Kiki Smith and Margaret Dewys, *Daughter*, 1999. Nepal paper, bubble wrap,
methyl cellulose, hair, fabric, and glass, 48 x 15 x 10 in. Courtesy of the Pace Gallery.

Figure 9. Claire Prussian, *Cinderella*, 1998. Two-part digital iris print, 7 x 10 in. Courtesy of the artist.

the young women? Are these really wolves and not predatory men? Why have we defamed wolves? Perhaps the wolves protect the young women. Perhaps the young women were born with blood-red hoods and capes from the wolves, as is suggested in the lithograph *Born* (2002; pl. 3). The wolf's hair appears to stream into the hairy capes and hoods of mother and daughter like blood or red flames. If women are born of wolves, they may inherit their intrepid character. *Born* is very much related to *Rapture* (2001; pl. 4), a stunning sculpture showing a full-blown woman emerging from a wolf's slit-open belly. While Smith relates this work to the medieval legend of St. Genevieve, who is said to have been born from a wolf's womb, she also notes that it evokes "Little Red Riding Hood as a kind of resurrection/birth myth."[3]

Smith's transformation of the female protagonists of fairy tales into confident and self-possessed women is brought about by a transformation of their bodies, dress, function, format, and relationship to their environments. In two other etchings based on Lewis Carroll's *Alice in Wonderland*, created in 2000 and 2003, Alice appears in two contexts: in one, she

appears in a pool of her own tears, anxiously fleeing some danger that obviously has frightened a strange group of fowls and animals (pl. 6), and in the other she sits on a hill and watches a flock of geese fly away from her (pl. 5). It is not clear why, but this Alice appears self-composed. The re-creations of Alice invite us to rethink the stories that we have been told about this girl. The new tales may not be happy, but like the texts of many feminist writers and critics, they will likely subvert the stories that we have generally been conditioned to believe are good for our children and our own souls, stories that many believe should not be touched. Feminist artists (no matter how political they may or may not be) are always touching things and messing them up. Kiki Smith has a magic touch that disturbs and enchants. She continually changes the female figures of fairy tales, myths, religious legends; she keeps them moving, reveals their multiple dimensions, and does not leave out the blood and gore. Like Rego, she is attracted to the dark and mysterious side of fairy tales and feels compelled to retell them with a feminist critique.

This critique is evident in numerous re-creations of fairy tales that are not in the present exhibition, and I would like to discuss some of these feminist artworks to show the large cultural context in which they are all working. For instance, Claire Prussian's fairy-tale works, which consist of digital Iris prints hung on top of and next to ornate wallpaper with patterns similar to the focus of the print, while not optimistic, are shockingly enlightening insofar as they compel the viewer to reflect on the glib happiness in fairy tales and nursery rhymes. In Prussian's prints Hansel ends up locked in a cage, and Gretel stands by helplessly. A forlorn Cinderella (fig. 9) stands against a garden wall with a broom and without a prince as she watches her stepsisters about to have their eyes pecked out. Little Red Riding Hood emerges from the bloody belly of the wolf on a black and white checkered linoleum floor. Prussian's images question whether happiness is possible in a savage world that appears covered up by the ba-

nality of homey wallpaper. In many respects, Prussian deflowers tales meant to deceive us by their innocent appearance.

In 2004 Sharon Singer produced an extraordinary body of oil paintings that expose and simultaneously penetrate deeper meanings of well-known fairy tales, offering brilliant and often disturbing insights into how they relate to momentous changes in our contemporary chaotic world. For instance, *Little Dread Riding Hood* (fig. 10) recalls the familiar tale of a naive girl gobbled up by a wolf, but this startling image gives the story a radically different slant: Singer's "Dread" Riding Hood is here a feisty young woman with dreadlocks seemingly riding on a wolf, tamed and muzzled. Different hues of "red like blood" add luster to a forceful young woman who is to be reckoned with, perhaps "dreaded" because of her courage.

It is interesting to note that almost all the contemporary feminist artists who have been concerned with fairy tales have focused on re-creating "Little Red Riding Hood," because it is the tale that enunciates the gender conflict and alludes to the problem of rape. An entire book, *Aftérouge* (2006), has been devoted to the collective memory of artists and writers who have been affected by "Little Red Riding Hood."[4] Aside from this collective endeavor, individual artists have been drawn to the story as well. In 2002, Vanessa Jane Phaff produced thirty-six silk-screen prints on canvas that retell the story of "Little Red Riding Hood" in an unusual graphic style recalling a children's picture book, except here the girl is courageous and smart and eventually appears to tame the wolf and sleep with him in bed. In 2009, Donna Leishman, a Scottish graphic and digital artist, produced two dissonant and subversive digital revisions of "Little Red Riding Hood" and "Bluebeard" that challenge the way we view, read, and hear classical fairy tales and permits us to intervene in the narrative.[5] Most recently, in 2010, Sarah McRae Morton produced a unique oil painting, *Red Riding Hood and Goldie Locks Encounter Each Other and Scandinavian Animals*, in her exhibition *The Marrow of Tradition*.[6] Here, too, the wolf appears

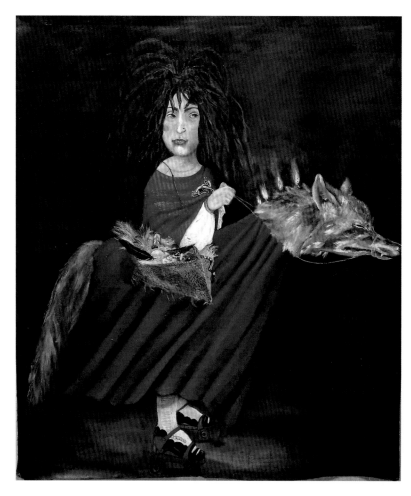

Figure 10. Sharon Singer, *Little Dread Riding Hood*, 2004. Oil on canvas, 59 ¹⁄₁₀ x 52 in. Courtesy of the artist.

harmless as Red Riding Hood meets Goldilocks in a surreal room filled with a deer and other animals.

The "Snow White" images are different but just as subversive. Elena Sisto's portrait of Snow White (1998) in oil on canvas depicts a fair-faced head on a pillow looking more like a comatose zombie than a beautiful princess. Dina Goldstein, a Canadian photographer, produced a fascinating photo series, *Fallen Princesses*, in 2009 that comments critically on the Disney world and raises many questions about the lives women are expected to lead and the lives that they actually lead. In her macabre portrayal of Snow White (fig. 11), she depicts the poor princess, who is the spitting image of Disney's heroine, standing in the middle of a suburban

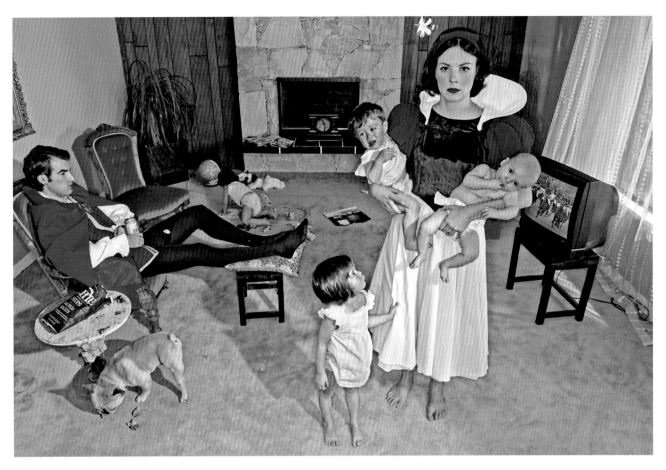

Figure 11. Dina Goldstein, *Snowy*, 2009. Giclée print, 30 x 45 ¼ in. Courtesy of the artist.

living room and staring solemnly into the camera while her princelike husband sits in an easy chair and watches television, totally detached from his family. Artists with a feminist inclination have touched up the classical fairy tales—"Snow White," "Little Red Riding Hood," and others—so that the gender conflict has become more pronounced, and what has been unacknowledged by traditional artists has become stunningly marked and recognized in their works.

Conflicted Mosaics

Whereas the re-created fairy-tale artworks always cite well-known narratives, the fairy-tale mosaics project other worlds filled with fantastic motifs that generally suggest happiness in classical tales. Yet happiness

appears to be elusive in these mosaics. The diverse images created by Meghan Boody, Walter Martin and Paloma Muñoz, Marcel Dzama, and Trenton Doyle Hancock are experimental compositions that collide with traditional images of fairy-tale settings and offer variations on the theme of fairy-tale otherness.

Meghan Boody has produced several series of extraordinary photos featuring strange characters placed in worlds in which they do not fit. For instance, in the bizarre pictures of *Incident at the Reformatory* (1995), human beings and animals assume erotic or everyday poses in baroque palatial settings made to appear ridiculous, for the animals are unsuitable for these fancy human constructions and the humans pose in outrageous positions. In the series *My Doll* (1996), Boody shifted the setting for her provocative arrangements to the icy white and frigid Arctic region

and satirically alluded to several of Hans Christian Andersen's fairy tales, especially "The Snow Queen." In the six staged photos, prepubescent girls are pictured in snowscapes playing strange games or mingling with gigantic animals: a walrus and a prehistoric elephant, as well as a mermaid. The young people are somber and appear to be indifferent to the icy waters and climate. They are out of place in an inclement world. In a statement about another series, *Henry's Wives* (1997), she remarks, "Like a sorcerer selecting the perfect blend of sacrificial ingredients for his brother, Henry succeeds in sampling six distant varieties of womanhood. He seems to have hit upon a winning combination. The archetypes typically ascribed to each (i.e., the Betrayed Wife, the Temptress, the Saint, the Sister, the Bad Girl, and the Mother) have served to lodge their images firmly in the collective psyche, casting a divine aura upon six women unhappy in love."[7] She likens Henry VIII to a "bellicose Bluebeard," and the six photos that focus on one queen each—three of which appear in the current exhibition (pls. 19–21)—tend to be satirical portraits of the women who succumbed to a decadent king, just the opposite of many queens and princesses in classical fairy tales. In the final image of the series, *In a Garden So Greene* (pl. 22), Boody appears to delight sadistically in the fate of the queens and King Henry. It seems as though Henry as the Frog Prince has drowned or is dying from swallowing too many golden balls (oranges). The garden is somewhat dilapidated. The five queens depicted, along with a nude girl on top of a fountain, have different reactions to the condition of the frog, including indifference, surprise, and concern. Clearly Boody's title plays ironically with the notion of some kind of verdant fairy-tale garden, which she pictures more like a backyard in disrepair populated by bizarre women caught up in comic antics.

As in Boody's images, the island panoramas and snow globes created by Walter Martin and Paloma Muñoz evoke the magical realm of the fairy tale, combining a deceptive beauty with a quality of dark irrationality. These works have a sense of stark alienation; in them, eerie tiny figurines perform odd acts, are trapped, or are traveling to nowhere. In an interview about their snow globes that appeared in the *Penleaf* in 2008, Martin and Muñoz stated, "The globe is an encapsulator. When all is said and done, it is essentially a novel framing device particularly well suited for the kinds of scenes we imagined. The sense of isolation and helplessness that permeates our narrative scenes is partly due to the intrinsic power of the snow globe format to encapsulate, miniaturize, and distort its subject matter."[8]

Generally speaking, store-bought snow globes contain serene scenes and characters and are associated with joyful childhood. Shake a globe, and the snowflakes fall gently. The world remains at peace with itself. This is not the case in Martin and Muñoz's snow globes. In the various globes, Humpty Dumpty is all alone and perched dangerously, about to fall into the snow (pl. 16); on a snow-covered cliff that features a barren tree, a tiny traveler approaches two enormous white rabbits that seem to be predators (pl. 15); on a snow-covered island with factory-like smokestacks, a black sheep races away from a herd of white sheep that is being transported to the mainland to be slaughtered; and a miniature man appears to force a woman onto a glacier. These are all puzzling images. In the humorous C-print on Plexiglas, *The Mail Boat* (2007; pl. 17), some strange pack animals are carrying the mail to a church while off to the side a man dressed in white speaks to a half-man, half-horse creature. There is an icy rock formation to the right, with a man in red jumping off a peak of the rock and two businessmen carrying briefcases and appearing to be discussing something on flat rock. Beneath them two men with horse heads are also in conversation. And so it goes. Parody and pain form the contours of the snow globes and other artworks of Martin and Muñoz. Their fairy-tale collisions are weird realms that do not augur harmony and happiness.

Marcel Dzama's sculptures of wood and glazed ceramic do not promise much happiness either. In the ironic work *Welcome to the Land of the Bat* (2008; pl. 14), cute but menacing white bats hover over a dying bear on a black background. There is something

terrifyingly ominous about this scene. Are the bats descending like vultures to eat the helpless dark blue animal? Who are these angelic-looking bats that thrive on a wounded creature? The original title for this diorama was *Infidels*, which designates an explicit political turn in Dzama's works. As Joseph Wolin has remarked,

> We might unpack allusions to current events from many of Dzama's new works, from the white bloodsuckers denoted as unbelievers (*Welcome to the Land of the Bat*) to a showcase of boyishly unabashed dissemblers [*La verdad está muerta / Room Full of Liars*] to the confluence of figures that can only be read as terrorists with some sort of sexualized power dynamic (*The Underground*). Dzama appears to have left behind the whimsy of his earlier, hermetic creations for a darker mode that acknowledges the darker world outside.[9]

For instance, even the cute Pinocchio assumes a more sinister shape in *La verdad está muerta* (2007; pl. 13)—which may be a reference to the mistrust Dzama felt for the Bush government—in which six puppets exhibit growing noses indicating the continual production of lies and corruption that extends into the present.

Other contemporary artists, such as Trenton Doyle Hancock, have also reformed fairy-tale worlds in compositions bound on a collision with traditional aesthetics and a status quo sensibility. Influenced strongly by expressionism, surrealism, the Bible, and comic books, Hancock has developed a fairy-tale narrative in his artworks, which include drawings, collages, oil paintings, and installations. Since the beginning of the twenty-first century he has continuously worked on a fantasy he calls "The Story of the Mounds." Using different modalities of art, Hancock depicts the battle between the half-human, half-plant mutants called Mounds and the Vegans, evil creatures who want to destroy all the Mounds. It is unclear who will triumph at the end of Hancock's

narrative, but his images, such as *Vegans Do Their Dirtiest Work* (2002; pl. 45), reveal that the world is never safe from the intruders who haunt his visions and narratives of other worlds.

Whether contemporary artists re-create traditional fairy tales or shape their own fairy-tale mosaics, their works clearly represent a discontent with the way their actual realities are configured and how social arrangements have been deformed. In fact, dissonance is the key to understanding all their works, especially those with fairy-tale motifs. This is why the recent fairy-tale artworks are so startling. Fairy tales originated and derived from wish fulfillment. They long served to compensate for the impoverished lives and desperate struggles that many people lead. Whatever the outcome of a fairy tale, there was some sort of hope for a miraculous change. There still may be hope in the fairy-tale collisions of contemporary artists, but it is tempered by the piercing truths of their imaginative visions, which compel us to re-create traditional narratives and rethink the course our lives have taken.

Notes

1. John McEwen, *Paula Rego*, 3rd ed. (London: Phaidon, 2006), 289.
2. Quoted in ibid., 138.
3. See Smith's statement on the Art 21 website, *www.pbs.org/art21/artists/smith/index.html*.
4. See Navid Nuur and Lisa Alena Vieten, eds., *Aftérouge* (Rotterdam, Netherlands: Uitgegeven door, Piet Zwart Institute, 2006): 5. The editors write: "The book *Aftérouge* arose from a fascination with images and stories that are part of our collective memory. This led to an interest in association. . . . More than fifty visual contributions are included in this book, all based on personal associations with the memory of the same story, the familiar fairy tale Little Red Riding Hood. In assembling the visual contributions we expressly requested images that would not so much illustrate the story itself, but are based on the memory of the story. Images that in a certain sense are comparable with afterimages, or with echoes, distorted repetitions."
5. See the works at *www.6amhoover.com/index_flash.html* (accessed June 7, 2010).

6. See the work at *mcraemorton.com/home.html* (accessed June 7, 2010).

7. Meghan Boody, "Artist Statements: Henry's Wives, 1997," *www.lookingglasslabs.com/statementC.html* (accessed June 1, 2010).

8. "Islands: The Art of Martin and Muñoz—An Interview with the Artists," *Penleaf*, February–March 2008.

9. Joseph Wolin, "The Haunting: Marcel Dzama's Traumatic Fantasy Worlds," *Canadian Art*, Fall 2008, 95.

Additional Sources

Blinderman, Barry, and Timothy Porges, eds. *Pixerina Witcherina*. Normal: University Galleries of Illinois State University, 2002.

Chadwick, Whitney. *Women, Art, and Society*. Rev. ed. London: Thames & Hudson, 1997.

Coldwell, Paul. *Paula Rego Printmaker*. London: Marlborough Graphics, 2005.

Engberg, Siri, ed. *Kiki Smith: A Gathering, 1980–2005*. Minneapolis: Walker Art Center, 2006.

Haenlein, Carl, ed. *Kiki Smith: All Creatures Great and Small*. Hannover, Germany: Kestner Gesellschaft, 1998.

Kingston, Angela, ed. *Fairy Tale: Contemporary Art and Enchantment*. Walsall, UK: New Art Gallery Walsall, 2007.

McEwen, John. *Paula Rego behind the Scenes*. London: Phaidon, 2008.

Nuur, Navid, and Lisa Alena Vieten, eds. *Rouge*. Rotterdam, Netherlands: Piet Zwart Institute, 2006.

Packer, Alison, Stella Beddoe, and Lianne Jarrett, eds. *Fairies in Legend and the Arts*. London: Cameron & Tayleur, 1980.

Posner, Helaine, and Kiki Smith. *Kiki Smith: Telling Tales*. New York: International Center of Photography, 2001.

Rosenthal, T. G. *Paula Rego: The Complete Graphic Work*. London: Thames & Hudson, 2003.

Weitman, Wendy. *Kiki Smith: Prints, Books and Things*. New York: Museum of Modern Art, 2003.

METAMORPHOSES *of the* MONSTROUS

Marina Warner

What Can Monsters Tell Us?

One of the greatest fantasy writers of modern literature, Jorge Luis Borges, compiled a sparkling modern bestiary called *The Book of Imaginary Beings*, first published in l967. Familiar monsters from antiquity (griffins, centaurs, Sirens, Harpies, the Hydra, the phoenix) are crowded in with creatures from different traditions of fairy tale and legend, such as the *Ch'i lin*, or Chinese unicorn, and the banshee from Irish folklore, the weird prophet of death who howls in the night. The inventions of literature by more recent writers whom Borges revered were also introduced into this marvelous menagerie: figments like the Cheshire cat from *Alice in Wonderland*, who famously fades away into a grin; the hobgoblins of Edgar Allan Poe; and the daimones of C. S. Lewis. To these sometimes troubling phantasms of the modern psyche, the Argentinean fabulist added a few monsters of his own imagining. For example, ever since childhood Borges had suffered from a terror of mirrors. In one of his most uncanny evocations, he describes "the Fauna of Mirrors": creatures who have been imprisoned in the looking glass but will awaken and "will break through the barriers of glass or metal."[1]

Some of Borges's fabulous beasts now fall into a subject area known as cryptozoology: enthusiasts report sightings of mutants, exotics, and hybrids made up of infinite combinations and projections, such as octopuses that live in trees and bizarre variations on human-animal unions.[2] Borges was writing before the huge new crop of fantasy creatures in popular culture, such as J. K. Rowling's teeming imaginary zoo in the Harry Potter books or the new breed of vampires and zombies from the Anne Rice novels, Stephenie Meyer's *Twilight* series and, most recently, the film *Monsters* (2010), about an outbreak of plague carried to the United States and Mexico by extraterrestrial beasts.

Has there ever been, since the triumph of the gargoyle in the Middle Ages, such fascination with the monstrous? Why have monsters returned with such force and taken such hold again of the popular imagination? What can they tell us? Why are young readers, adult filmgoers, and artists and writers today drawing on fairy-tale fantasy and mythological symbolism from the past to fashion new sports and wonders? This turn toward the grotesque and the bizarre is producing work at very different emotional registers, as the exhibition *Fairy Tales, Monsters, and the Genetic Imagination* demonstrates: lavishly, uncompromis-

ingly nightmarish and ghoulish (David Altmejd; pls. 32–33); sympathetic, fierce, and tender (Kate Clark; pl. 18); playful and eerie (Saya Woolfalk; pls. 70–71); and deliberately strange and dystopian (Patricia Piccinini, who called a recent show *Not as We Know It*; pls. 52–57). A desire to provoke wonder through astonishment, surprise, and novelty underlies the fabrication of monsters; the forms of attention that artists are giving to this tradition of monstrosity seek to provoke strong reactions and visceral sensations. Such experiments with form often run against the canon of taste, but it is clear that making beasts, monsters, and metamorphoses in any medium produces rich meanings at an ethical as well as personal level.[3]

Monstro means "I show" in Latin, as in the words "demonstrate" or "monstrance," the precious, haloed vessel in which the Eucharist is displayed to the congregation. But "monster" also includes the memory of the verb *moneo*, meaning "I warn" or "I advise," as in "monitor" and "admonishment." The genre of the monstrous still enfolds these associated functions of showing and alerting, of making something visible and also announcing future possibilities. Consequently monsters give artists a way of thinking about issues of our times, with regard first to nature, scientific experiment, and ecological survival, and second to changing ethics of the self and sexuality. But a monster is also an enigma, irregular and inexplicable, manifesting a body that contradicts the ordinary course of bodies. It is significant that the word "griffin" is close to another term for a riddle—"gryph"—as well as to the Greek word for sign, "glyph." Griffins' composite bodies, with parts of lions and eagles and dragons, inspired Lewis Carroll to introduce his Gryphon as one of the dominant characters in the Alice books, which are themselves packed with riddles and riddling thoughts. The connection between griffins and riddles (which the literary critic Eleanor Cook has explored in a lively study) gives us an insight into a generic aspect of such marvelous monsters: medieval or contemporary, they act as complex signs and wonders with shifting meanings.[4]

Relations with such enigmas, with monsters real and imaginary, call into play the very concept of metamorphosis, as both natural event and metaphorical transformation. Metamorphosis entails a fluidity of categories: in Ovid's great poem in fifteen books, rocks turn into human beings, nymphs and young men into rivers, trees, and flowers. Such shifts in the identity of phenomena come about through the acts of the gods—chiefly as revenge on human beings (less often as rewards). Familiar fairy tales often unfold similar motifs to the myths (the Beast in "Beauty and the Beast" is being punished by his change of shape), but in these stories, animal metamorphosis gives a character a way of facing fears about degradation, and of confronting in the process forbidden sides of experience, since animality frequently symbolizes sexual hunger or sexual isolation. Fairy-tale beasts and monsters, in stories by Charles Perrault, Marie-Catherine d'Aulnoy, the Brothers Grimm, and Hans Christian Andersen, open the human self to reexamination, and to a search for human creatureliness; with characters like the Frog Prince, the bear in "Snow-White and Rose-Red," or the Little Mermaid, the genre of the monstrous allows an artist to move between make-believe and mythic symbol, between an imaginary animal and a psychological or ethical category of human being, between being a beast and being beastly or bestial, with the full range of qualities that implies.

The changing value of beastly metamorphoses today still remembers and uses the old links to fear and aversion, and the language in which the new transformations are couched is strongly connected to the imaginative tradition which gave rise to medieval illuminations of devils and grotesques. But while the tradition offers raw material of image and metaphor, their meanings are being radically changed in interactions with psychological, ethical, and scientific developments. The eventuality of falling outside the human species altogether no longer holds such a threat, and contemporary artists are actively engaged in this work of reconfiguring monstrosity. To achieve these realignments of meaning and feeling, artists

are making works that communicate empathy and identification with the monsters; they perform inversions, parodies, and ironical takes on conventionally assigned values; they give rein to carnivalesque riot and comedy; and they indulge in excess, violence, and disfigurement—monstrousness dealt with monstrously. The variety of metamorphoses they communicate can *transvalue* their subjects, so that a monster or a beast acquires another character, not simply by rising in a hierarchy but by drawing down new perceptions toward his or her condition. This kind of art often has a political, feminist, anti-imperialist thrust, as it revisions formerly despised and rejected low-life forms—insects, corpses, and abject, *informe* (formless) monstrous creatures which have threatened human beings since the beginning of myths.[5]

Genesis and Generation

The genetic imagination was active in fashioning the original generation of supernatural phenomena. Ancient cosmic myths from Babylon to Athens generated myriad monsters and hybrids and situated them in a historical and geographical perspective: they exist at the beginning, in the primordial chaos of genesis. In the *Theogony* by Hesiod, these prodigies are literally the progeny of primordial Chaos, of the union between Uranos the Sky and Ge the Earth, and they include beings that embody generative energy in an inchoate, uncontrolled state, such as Typhon and Echidna, who are the parents of the monstrous, three-headed Chimera. Huge scale, multiplicity, and heterogeneity of limb and features distinguish this generation of divine powers from the two-legged, upright, anthropomorphic Olympian gods who vanquish them: all the hundred-handed giants, one-eyed Cyclopes, fiery dragons and colossal serpents, snake-legged godlings, and devouring and terrifying monsters at the beginning of time do battle with the coming generation—and with superhumans like Heracles—and are defeated.

But defeat does not always entail the death of these imagined powers of primordial existence. In several stories, such as the myth about the fate of the giants, they are bound and cast down into the underworld. There, they sometimes heave and groan, causing the earth above to quake or volcanoes to erupt. Such monsters represent an originary, savage condition that the divine pantheon and human civilization have overwhelmed and surpassed. (They also communicate the fear that this is only a pious wish and disorder can be unleashed again, at any time.) Classical metamorphosis takes place within this hierarchy of phenomena: to be turned into a monster or an animal is a terrible fate or, at best, a reprieve from an even worse penalty. When King Lycaon, in the first book of Ovid's poem, is changed into a werewolf, he is being punished for his foul behavior—he killed a hostage and then served him in a pie for dinner to his guest. He loses his status as a man and a king and is condemned to bear the marks of his bestial nature on his body.

Similarly, in the Book of Daniel in the Bible, Nebuchadnezzar, the king of Babylon, is condemned to live as a beast and eat grass, with matted hair "like eagle's feathers" on his body and his nails growing long and talonlike (Dan. 4:33). The manuscript illumination from the *World Chronicle of Rudolf von Ems*, painted in Germany around 1400–1410, conveys the sorrow Nebuchadnezzar feels at his debased animal state (fig. 12). In this story, his transformation into a beast knocks him down from his proud pedestal, where he had preened himself on his godlike glory and power. He realizes the error of his ways and is allowed to return to his human dignity. In popular consciousness today, the hybrid human-animal Gollum from *The Lord of the Rings*, who has been corrupted by his love of the "Precious," the ring of the title, epitomizes this threshold state of being. (He was dazzlingly realized in the films of the book by the actor Andy Serkis, whose actual body and movements were grafted onto a chimera conjured by the latest techniques in computer-generated imagery.)

The correlations between monstrosity and evil

smoothed the path toward a moralized interpretation that Christian thinkers developed when they annexed and redrafted the irresistible population of the pagan bestiary. Under theological and pastoral direction, medieval artists transformed classical marvels or mirabilia and monsters into a teeming and fearsome allegory of moral evil. But even as Christian artists plundered the fertile imagination of antiquity, their faith realigned the values to conform to a new dualism that assigned all moral error, deviation, and evil to a devil and his agents. This departs from the pre-Christian worldview, in which chaos and wildness, sickness and death were the greatest evils but did not proceed directly from the malignancy of a supernatural power. They were instead the inexorable workings of fate, and of *Ananke*, necessity. The fantastic devils who writhe under the trampling of angels and saints are modeled on monstrous classical predecessors in form, but not in meaning.

Hybrid bodies, mixing and matching different physical limbs and features, mark out these creatures. They clash with the standards of nature and the properties of phenomena according to Aristotelian biology, which clearly demarcated genera and species and determined their qualities, excluding singularity from the taxonomy. Greek ideas about primitive peoples and barbarians also threw a long shadow. Incongruity and deviancy from what was considered the standard and natural shape attracted negative values—Aristotle was particularly severe, and even considered the female "a defect in nature" because women differed from the default shape of the human being, which was male. Medieval images frequently collapse the imaginary into prejudice. Racist and anti-Semitic conventions leak into the iconography of beasts and monsters, especially when the imagery of barbarians and the imagery of beasts converge and are both categorized as not only inferior but also dangerous. Monsters traditionally marked out a space of error, and the association of error quickly turned metaphorical: puns on concepts such as "fault" follow the logic of dreams, when metaphors turn from descriptive to figurative

Figure 12. Unknown, *Nebuchadnezzar as a Wild Animal*, ca. 1400–1410, with addition in 1487. Tempera colors, gold, silver paint, and ink on parchment, 13 ³⁄₁₆ x 9 ¼ in. J. Paul Getty Museum, Los Angeles. Ms. 33, fol. 215v.

and anxieties materialize as horrendous beings often pursuing the dreamer through fires and floods or other apocalyptic scenery. With regard to the appearance of imaginary fauna, any departure from the standard model constitutes fault, and this fault turns into a perversion: culpable disfigurement. Monstrous bodies became allegories of sin and human wrongdoing, and the devil and his minions took on their highly recognizable motley and fantastical monstrous shapes.

In the Bible, the devil makes many different appearances; he is a master of disguises as well as the master of lies. Some attempt to systematize his manifestations still goes on, and in the Book of Revelation, John sees the vehicles of evil rolled into one: "The great dragon, the primeval serpent, known as the devil or Satan, who had deceived all the world, was hurled down to the earth and his angels were hurled down with him" (Apoc. 12:9). The Bible also calls the devil Beelzebub, the Lord of the Flies, a name that inspired Hieronymus Bosch to depict insectlike demons, and Christian artists to mix and match elements from insects with various reptiles and arthropods—claws

Figure 13. Attributed to Willem Vrelant, *Adam and Eve Eating the Forbidden Fruit*, early 1460s. Tempera colors, gold leaf, and ink on parchment, 10 ⅛ x 6 ¹³⁄₁₆ in. J. Paul Getty Museum, Los Angeles. Ms. Ludwig IX 8, fol. 137.

and beaks and scales and wings and antennae. Artists also frequently reached for imagery of pagan deities: Pan and the fauns and satyrs of classical erotica bequeathed to the Christian Satan their cloven hooves, their tails, their furry limbs.

The most familiar form taken by the devil, however, remains the serpent, as in the famous smooth-tongued snake in Eden. Interestingly, medieval artists read into the story of the fall a specific character of the serpent, and often gave that deceptive tempter a woman's face and breasts, as in one miniature from a Book of Hours painted in the early 1460s in Bruges (fig. 13). The serpent here has the elaborately braided hair of a mature woman—perhaps with an implication

of luxury and vanity too—while Eve's long golden hair falls to her thighs, as characterizes young women, and especially virgins, in medieval illumination: she is about to be corrupted. Sometimes, the devil and Eve double each other's appearance more exactly. In both cases, the female tempter under the Tree of Knowledge presents a theological reading of the story of the fall: Tertullian wrote in the third century that Eve was the devil's gateway. It was early church doctrine that sin had entered the world through woman, and that it would be saved by another—the Virgin Mary, the Second Eve.

The devil's ability to change his sex as well as his shape inspires a trope much relished in the stories of saints' struggles against temptation. Hermits who dedicate their lives to utter deprivation and complete solitude in grim deserts tend to be visited by wild fantasies of pleasure—this happens to St. Anthony Abbot, most famous of the early desert fathers. According to the hagiographical account of his heroism, St. Anthony had to endure horrible torments by devils in multiple hybrid forms, who were so tenacious they lifted him up into the air as they bit him and mauled him, as Martin Schongauer captures with fantastic inventiveness in his engraving (fig. 14). But among these fiends, of course, there were also women. Like St. Jerome, who retired to fast in penance in the Holy Land and found himself courted by bevies of dancing girls in his dreams, St. Anthony received alluring visits from lovely young women; however, as the depictions of his torments often show, their wicked nature is betrayed by the devilish clawed feet peeping under the hem of their gorgeous apparel (fig. 15).

Women artists today are consciously challenging the tradition of feminizing the monstrous, and are moving to take up occupation of the places of terror and danger which monsters represent; in the process they redraft ideas of beauty, decorum, and propriety. Cindy Sherman (pls. 34–35) pioneered this powerful critique through her numerous impersonations and performances of conventional female roles, many of

Figure 14. Martin Schongauer, *Saint Anthony Tormented by Demons*. Engraving, 11 ¹³⁄₁₆ x 8 ⁹⁄₁₆ in. (sheet). The Metropolitan Museum of Art, New York. Rogers Fund, 1920 (20.5.2).

Figure 15. Lieven van Lathem, *The Temptation of St. Anthony*, 1469. Tempera colors, gold leaf, gold paint, silver paint, and ink on parchment, 4 ⅞ x 3 ⅝ in. (leaf). J. Paul Getty Museum, Los Angeles. Ms. 37, fol. 33.

which confront directly the association of woman with both evil and magical power.

Among contemporary artists, it is perhaps Kiki Smith who has most sympathetically aligned herself with such fallen women, as well as with the heroines of fairy tales and stories such as *Alice in Wonderland*.[6] Smith was born and raised a Catholic, and she still has a strong emotional attachment to the faith and is steeped in its iconography and symbols, even giving her own face to the lizardlike devil from Hugo van der Goes's painting of the fall in a series of drawings and works on glass, called *Play* (fig. 16).

Whereas Catholic tradition insists, in a spirit of warning, on equating women with nature, and hence with weaknesses of the flesh, in many works Smith reclaims animal kinship with pride. She identifies with the monsters and the sinners, with Harpies and Sirens, with Eve, Lilith, and the penitent Magdalene, and reasserts the value of flesh-and-blood bodies and of our carnal, fallen state. Even when plunging into traditional zones where women have been negated and condemned, Smith keeps up her spirit of energetic contradiction. Using the language of metamorphosis, she once remarked in a conversation with her friend and fellow artist Chuck Close about the relationship between suffering and creativity, "You have a certain amount of regrowth. Like reptiles whose tails grow back, or a worm cut in half. We don't tend to think of that, regeneration."[7]

Many other contemporary artists are aware of these possibilities that the world of monsters holds for their work. In their engagement with monstrosity, they are energetically shaking the classical legacy and attacking Judeo-Christian attitudes toward beasts and definitions of disorder and danger, evil and sexual transgression. Medieval beasts as symbols are providing metaphors and motifs, but they are being stripped of their diabolical connotations—or rather, those diabolical associations are being recast, reconfigured, turned upside down, and transfigured. The imagery of the monstrous is being introduced dynamically into an ongoing conversation we human creatures are conducting with other animals; attitudes toward beasts

Figure 16. Kiki Smith, *Play (Serpent with Apple III)*, 2000. Ink and colored pencil on paper, 89 x 40 ¼ in. Kukje Gallery, Seoul.

are continually entangled with ideas about ourselves as humans in relation to them, and about where boundaries lie and how the classifications establish hierarchy. Although the shadow of possible human evil, not only physical singularity, is still cast by the tradition, the monstrous today almost always contests this simple view and picks up instead on the playful ambiguities in the tradition: medieval monsters, even when they are shown attacking saints or tempting hermits, are often conceived with marvelous fancifulness. The effect is less minatory and edifying than entertaining and appealing: whereas traditionally the princess was horrified to find the Frog Prince sitting on her pillow, Shrek has become a lovable pinup and cuddly monsters in the form of soft toys are now heaped on children's beds.

Beasts used to embody deep dangers to the heroines, but the tendency has been to invert former negative values attached to the animal state, as found in nature or invented in myths and fables. In Angela Carter's 1979 retelling, for example, Little Red Riding Hood finds herself happily in bed with the wolf at the end of the story: "See! how sweet and sound she sleeps in granny's bed, between the paws of the tender wolf."[8] Smith takes a cue from Carter with her own variants on the story of Red Riding Hood (and Alice in Wonderland). The monumental bronze sculpture *Rapture* (2001; pl. 4) dramatizes the moment when the

gobbled victim is freed from the belly of the wolf in the version by the Brothers Grimm: a mature, naked, radiant woman steps out of the carcass as if she were not the animal's victim but the emanation of its animal energy. Here, Smith's approach shows how the axioms that have traditionally structured feared or repulsive living things are themselves changing nature. Smith's aesthetic can then set off a chain reaction of metamorphoses, sparking in the minds of her viewers further changes in their ways of seeing and understanding the condition of physical embodiment experienced by all living things in the world. She has dived deep into zones of abjection, but neither horror nor repulsion is of interest to her as a response, even though several early works leaned toward the grotesque and shocked and stirred viewers.[9] Increasingly, Smith's works realign responses to physical phenomena and foster a new, creaturely empathy, leading one to recognize Smith herself in the beasts with whom her Alice swims in the pool of tears (pl. 6).

Chimera: The Infinite Horizons of Fantasy

While the beastly used to warn of danger and evil, monsters began to be invoked as standards of comparison in the catalogues of scientific medicine in the Enlightenment. The attempt to define the physical norms of human nature and health paradoxically led researchers to draw up criteria of the nonhuman and the "abnormal," thereby warranting exclusion. Pioneering anatomists in the eighteenth century, such as William and John Hunter, collected examples of "freaks," of deformations and defects, in order to regulate the norms of physical characteristics. Such medical work did, however, give rise to a third stage in ideas of the monstrous: it became a site of curiosity, wonder, and desire, where ordinariness could be escaped and the originality of the exceptional case achieved.

The Chimera, the child of the chaotic powers Typhon and Echidna, offers a case study of changes over time to ideas of monstrosity. The Chimera began

life as a classical she-monster and has now become a medical term for a product of bioengineering. Originally a three-headed, fire-breathing, dragonish kind of beast, the Chimera of myth was killed by a hero, Bellerophon, who flew on the winged horse Pegasus; when Bellerophon speared her, the metal melted in the heat of her breath in all three of her gullets and suffocated her. By the seventeenth century, the monster had ceased to be a singular mythical individual, a phenomenon with a narrative of her own; instead, her name acquired an allegorical meaning, and the word conveyed illusion in the sense that Shakespeare evokes when Theseus comments, in *A Midsummer Night's Dream*, "Such tricks hath strong imagination . . . How easy is a bush supposed a bear." The Chimera became an image of fantasy's powers to summon the unreal; Ginevra Bompiani goes so far as to declare it "the metaphor for metaphor itself."[10]

In the late eighteenth century, French artist Jean-Louis Desprez accepted the classical monster's tricephalous form and showed her devouring an unfortunate victim; he has been half swallowed—the two outer heads are devouring his hands, while the central beaked head pecks at his face (fig. 17). Devouring frequently characterizes monsters—ogres, devils, and rampaging beasts—in the mythic imagination, with the horror of cannibalism (eating human flesh) looming large as part of their "unnatural" character: the Minotaur demands a yearly tribute of young Athenians, and the Christian Hell as dramatized by Dante climaxes in the giant figure of Satan as he endlessly devours the traitors Judas, Brutus, and Cassius. The vision of Chimera in Desprez's engraving departs from the classical myth and intensifies the macabre, gothic horror of the monster, adding oversize Bosch-like insects in the foreground, squatting above a bat with spread wings. But his drawing is also cartoonish in its overreaching and histrionics, and it elicits laughter from the spectator—perhaps nervous laughter, but still laughter. This "horrid laughter," filled with ambivalence, has become more marked in responses to the manifestations of the monstrous in modernity.[11]

The idea of illusion and the unpredictable and

Figure 17. Jean-Louis Desprez, *The Chimera*, ca. 1777–1784. Etching, 11 5/16 x 14 7/16 in. (sheet). The Metropolitan Museum of Art, New York. Purchase, 1998 (1998.248).

irregular combinations of features which make up the mythical Chimera led twentieth-century scientists to take her name and give it to the biologically engineered organisms they can now create in the laboratory. These hybrids (known as "sports" of nature in biology) include transplants for which different species are spliced together, often with a medical hope for restoring a limb or grafting skin, as when an ear is grown on a mouse for future transplantation to a human. Such chimeras are no longer illusions or tricks but new beings with huge potential for healing or harm.

The insistent, metamorphic presence in contem-porary culture of legendary beasts arises from these promethean powers as biology and medical science create phenomena only dreamed of in divine myth and medieval fables. Cloning, stem cell research and other reproductive technologies, "cyborg" prostheses, the transplantation of animal organs and cells into humans, and the genetic modification both of foods and, ultimately, of ourselves have turned metamorphosis into a newly urgent problem. It haunts the fantasies of cosmetic pharmacology and surgery: endless self-fashioning, self-modification, beautification, and rejuvenation.

The biologist Freeman Dyson, a great sage of our

Figure 18. "Mermaid," Javanese ritual figure, ca. 1840–1870. Science Museum, London.

time—when he wrote the article quoted below, he was age eighty-seven—has conjured up a remarkable picture of a future when biological interventions, he prophesies, will have transformed the ecosystem. He imagines many fabulous creatures whom Borges might well have included in his bestiary, including genetically engineered worms that will eat cars and pick out precious rare metals from mobile phones and other electronics. In a highly contrary spirit, he paints this utopian vision:

> Domesticated technology, once it gets into the hands of housewives and children, will give us an explosion of diversity of new living creatures. Designing genomes will be a personal thing, a new art form as creative as painting or sculpture. . . . Few of the new creations will be masterpieces, but a great many will bring joy to their creators and variety to our flora and fauna. The final step in the domestication of biotechnology will be biotech games. . . . Playing such games, kids will acquire an intimate feeling for the organisms they are growing. The winner could be the kid whose seed grows the prickliest cactus, or the kid whose egg hatches the cutest dinosaur.[12]

Dyson welcomes these innovations and urges us to welcome them with him. He calls his vision "green biology," and while he recognizes its dangers, he proclaims its inevitability and, consequently, the real need for us to think through the ethics of these developments and the practices involved. But for many of us—perhaps even most of us—this vision of the future is not painted a bright, living green, but rather has a sulphurous and livid hue, a diabolical tinge. The prospect of kindergarten children hatching chimeras moves into nightmare territory, closer to the science-fiction novel *The Day of the Triffids* (1951) than to a miracle cure for cancer. And he limits his prophecies to real creatures with biological life; he leaves out the Tamagotchis, robot companions, virtual pets, as well as the immaterial figments of literary imagination, like Hedwig the Messenger Owl, who caused great grief to children when she died (at the hands of her creator) in the closing book of the Harry Potter series. These strictly chimerical phenomena, which have kinesis but not sentience, presence but not substance, animation but no anima, are nevertheless capable of inspiring strong attachments and long-term, profound relationships, as Sherry Turkle explored in her pioneering work *The Second Self* (1985) and in the more recent collection of essays *Evocative Objects* (2009).

Digitization has made possible illusory beings, wrought to an unprecedented apogee of lifelike-ness and invention, and several artists have entered this uncanny and troubling territory. Historically, this fictive arena of the uncanny was occupied by automatons, like the doll Olympia in E. T. A. Hoffmann's celebrated story "The Sandman" (1816), and by waxworks and their close cousins, the taxidermist's specimens. These artifacts were made for show, and their history interlocks with the fortunes of monsters, which were often stuffed—or concocted—to be exhibited in touring circuses (freak shows) and other entertainments. For example, "the Feejee mermaid" was a tremendous hit when a returning sailor showed her to the Victorian public (she was concocted from a monkey's head and salmon's body) (fig. 18).[13] It

is significant how many contemporary artists, while adopting dematerialized cybernetic processes, draw on these older, material methods of the ceroplast (the wax sculptor), the doll and puppet maker, and the taxidermist to achieve their objects. Meghan Boody has produced dioramas of stories from classical myth, in her sequence *Psyche and Smut* (pls. 23–28), and from the annals of history, in her dramatic revisioning of the six wives of Henry VIII (pls. 19–22). The Chapman brothers, Dinos and Jake, are specialists in *tableaux vivants*, for which they have gleefully grafted limbs and organs to a very high pitch of verisimilitude, producing scandalous deformations and deliberately flouting all shared norms of decorum and respect. In their series of variations on the surrealist game "Exquisite Corpse," they continue to mix and mingle body parts, still aiming to induce powerfully mixed responses: the defensive laughter of the grotesque and a visceral revulsion against denatured forms (pls. 40–43). Their chimeras, like David Altmejd's composite monsters, are extreme in their invention and all the more alarming because they are presented as technically feasible.

Beasts "R" Us

In classical art history, "grillus" is the proper term for one of the combinatory creatures so richly devised by Bosch and Brueghel; counterparts to chimeras, grilli often play most actively on the margins of medieval manuscripts, occupying a territory that is offbeat and out of bounds, like the unruly underworld zones where the giants and other chthonic beings of ancient monster lore were thrust when they were defeated. The great art historian Meyer Shapiro saw marginal erotica or jokes as expressions of the artists' unconscious—the repressed surfacing, the libido reasserting itself, and their minds idling, doodling as they daydream. More recently, Michael Camille opposed this view and argued instead that the margins of medieval illuminations convey the artist's own fantasy consciously at work, whereas the main image on the page must follow the traditional teaching about the gospels or the liturgy.[14] Weird grilli and other imaginary creatures and monsters contain self-portraits, in Camille's opinion, symbolic images not only of the artist but also of the owner of the prayer book, who was often a woman. Camille suggests that the small furry animals are a pun on genitals to recall women to their status as occasions of sin. "Human sexuality was but a further ineradicable trace of fleshly, fallen human nature. It was because sex was marginalized in medieval experience that it so often became an image on the edge." "Medieval people," he continues, "felt themselves too close to the beasts . . . to see the margins as anything other than the site of their wallowing, fallen co-existence."[15]

These thoughts can be applied, somewhat modified, to monstrosity in its contemporary manifestations. But Camille's sober angle on marginal beasts misses the blithe glee of their antics and the twin pleasures of discovery and laughter that they bring: they spring a surprise, almost concealed, certainly unexpected. They have come in from the edge to make edginess the effect of their presence, and to give important matters center stage. In the Middle Ages, from the margins of illuminated manuscripts, monsters helped press richer, fuller meanings to emerge from the central pictures. Today, through artists' comparable inventions—the new grilli, chimeras, and metamorphoses—we are given an insight into possibility, an insight which includes a promise and a warning about the variety, heterogeneity, and possible combinations and recombinations in the order of things.

The lively appearance of such fantasies stakes the future on this poetic logic, which derives, on the one hand, from the dream power of metaphor to institute alternative realities and, on the other, from the force of irony, the strategic inversion and undermining of patent meaning. Borges did not say that the Fauna of Mirrors were the reflections of his own unacknowledged phantasms. But the entry in his bestiary implies it, and it is artists—and writers—who wake up the monsters from behind the barriers of glass and metal and force them on our attention, to realign conven-

tional responses and beliefs while casting skepticism itself into doubt. The artistic imagination can bring such creatures forth, for the created world does not represent the full range of manifest phenomena. This is an alarming thought—but it is also an exciting one.

Notes

Part of this essay was included in a lecture given at the Getty Museum on July 22, 2007, in connection with the exhibition *Medieval Beasts*, May 1–July 1, 2007; see *www.getty.edu/art/ exhibitions/medieval_beasts*. Monsters and their representations have been central to my work, and this essay shares thoughts with my books *Monsters of Our Own Making* (Lexington: University of Kentucky Press, 2007) and *Fantastic Metamorphoses, Other Worlds* (Oxford: Oxford University Press, 2002), esp. Introduction; see also my essay "Satyrs, Spiders, Jellyfish, and Mutants: Ovidian Metamorphosis in Contemporary Art," in *The Body and the Arts*, ed. Corinne Saunders, Ulrika Maude, and Jane Macnaughton (London: Palgrave Macmillan, 2009), 186–209.

1. Jorge Luis Borges, with Margarita Guerrero, *The Book of Imaginary Beings*, trans. Norman Thomas di Giovanni with the author (New York: Dutton, l969).
2. See, for example, Loren Coleman, "Top Ten Cryptozoo Mystery Pics," *Cryptomundo*, December 16, 2006, *www.cryptomundo.com/cryptozoo-news/2006-cz-pix*.
3. In 2004, I addressed such ideas through an exhibition for the Wellcome Trust called *Metamorphing: Mythology, Art, and Science*, held at the Science Museum in London. With the writer and historian of science Sarah Bakewell, I selected items from the Wellcome's medical and scientific collections as well as works of contemporary art, and organized them into different sections exploring such themes as individual and species transformation, evolution, healing, prostheses, regeneration, and cosmetic bodily modification. See the new study by Wes Williams, *Monsters and Their Meanings in Early Modern Culture: Mighty Magic* (Oxford: Oxford University Press, 2011).
4. Eleanor Cook, *Enigmas and Riddles in Literature* (Cambridge: Cambridge University Press, 2006), reviewed in Marina Warner, "Doubly Damned," *London Review of Books*, February 8, 2007, 26–27.
5. The literature on the informe is extensive. See especially Julia Kristeva, *Powers of Horror: An Essay on Abjection*, trans. Leon S. Roudiez (New York: Columbia University Press, l982), and Yve-Alain Bois and Rosalind E. Krauss, *Formless: A User's Guide* (New York: Zone Books, 1997).
6. See Marina Warner, "Wolf-Girl, Soul-Bird: The Mortal Art of Kiki Smith," in Siri Engberg and Linda Nochlin, *Kiki Smith: A Gathering, 1980–2005* (Minneapolis: Walker Art Center, 2005), 42–54.
7. Quoted in Chuck Close, "Kiki Smith," *Bomb* 49 (Fall 1994): 40, *bombsite.com/issues/49/articles/1805*.
8. Angela Carter, "The Company of Wolves," in *The Bloody Chamber and Other Stories* (1979; repr., London: Vintage, 1995), 118.
9. The aesthetic of the abject, discussed by Kristeva in *Powers of Horror*, remains closer to the Catholic cult of suffering than Kiki Smith's reevaluation of its forms. See Simon Taylor, "The Phobic Object: Abjection in Contemporary Art," in *Abject Art: Repulsion and Desire in American Art* (New York: Whitney Museum of American Art, 1993), 59–83.
10. Shakespeare, *A Midsummer Night's Dream*, act 5, sc. 1, ll. 18, 22; Ginevra Bompiani, "The Chimera Herself," trans. Margaret Roberts and Frank Treccase, in *Fragments for a History of the Human Body*, ed. Michel Feher, Ramona Naddaff, and Nadia Tazi (New York: Zone Books, 1989), 1: 377.
11. See Nicholas Brooke, *Horrid Laughter in Jacobean Tragedy* (London: Open Books, l979).
12. Freeman Dyson, "Our Biotech Future," *New York Review of Books*, July 19, 2007. The article excited spirited debate in the letters column: correspondents did not share the writer's hopeful views of bioengineering. See *New York Review of Books*, September 27 and October 11, 2007.
13. See Jan Bondeson, *The Feejee Mermaid and Other Essays in Natural and Unnatural History* (Ithaca, NY: Cornell University Press, 1999), 36–63.
14. Michael Camille, *Image on the Edge: The Margins of Medieval Art* (London: Reaktion Books, 1992), 39–40. Dana M. Oswald's *Gender and Sexuality in Medieval English Literature* (Cambridge: Boydell and Brewer, 2010) was published as I was writing this essay and so unfortunately I was not able to read it in time.
15. Camille, *Image on the Edge*, 39–40, 48.

THE EXTANT VAMP (or the) IRE of IT ALL: FAIRY TALES and GENETIC ENGINEERING

Suzanne Anker

Fairy, Fairy, Mary, Mary, how does your garden grow?
From sulphur bells to cockleshells to test tubes
lined up in a row.

In the beginning, once upon a time, or many years ago in a faraway place, the story you are about to hear is true, but the names have been changed to protect the innocent. Narratives, mythologies, ideologies, and theologies all bring to the fore accounts of recurrent archetypes. How these archetypes come to be, what they mean, and what eventually results from their quests, queries, and vexations is the stuff of imagined worlds and psychocentric study. However, what is ciphered from these tales are repetitive forms and means, employed to reconstruct fictions of the "readymade." If fairy tales have entered the current domain of art, then questions arise as to why there is such an eruption at this point in culture.

Like cell samples or botanical specimens, fairy tales are also formed into collections. As stories from an oral tradition are retold and codified to produce volumes (as in the work of Hans Christian Andersen or the Brothers Grimm), the Victorian fairy tale moves up the ranks in social class. These volumes form a data bank, like all exemplars of symbolic matrices. Reuse of the extant, so prominent a feature of collage, montage,

and appropriation, is a framing device for these collective narratives as well. Currently, the Frankensteinian mashup in videos, web browsing, and music expands on such combinatory practices. Within the scientific realm, the readymade has become a resource in xenotransplantation, tissue culturing, and reproductive technologies.[1] While the readymade and its reuse through recontextualization is one of the prime strategies of twentieth-century visual art practice, in the twenty-first century, art and science conceptually share this methodology.

Emerging from the swells of enchantment, the marvel is imbued with supernatural powers. Are superheroes, witches, fairies, and monsters merely fabrications of the mind? Are these strange, bizarre, and marvelous creatures aspects of the imagination? Or might they, in fact, be real? Recently such fanciful creatures have come to populate scientific laboratories, in the form of tobacco plants that glow in the dark, tomatoes that are frost resistant, and pigs that produce human insulin. The depths of visionary thinking which manifest such wonders have revamped the stuff of dreams into corporeal matter. Chimeras, genetic manipulations, and bioengineering have entered the phantasmagoric realm.

As hybrid forms, chimeras are composite figures

resisting discrete Linnaean species boundaries. The chimera has appeared and reappeared in myriad guises over centuries in numerous and various cultures. As early as prehistoric times, the chimera appears inscribed on cave walls in Lascaux, with the body of a man topped by a bird's head. In mythology chimeras take the form of amalgams. Prime characterizations of chimeras also populate H. G. Wells's evolutionary parable *The Island of Dr. Moreau* (1896). Written at a time when distinctions between animals and humans were being vigorously debated, especially with regard to vivisection, this enchanting novel is a discourse on the continuity and discontinuity between man and beast—a border zone encapsulating significant bioethical concerns. Dr. Moreau, the novel's protagonist, is engaged in surgically constructing animal-human hybrids, combining man and dog, cat and woman, and so on. Herein beasts are given human attributes, thus scaling up or down evolution's clock. More recently, in biology, the term "chimera" has taken on another definition: an animal or plant composed of cells from distinct species. These chimeras come into being in a variety of ways. Some are naturally occurring, some are fabricated in the lab, and others are the result of organ transplantation. Popular culture also enters the fray with what else but a plushy chimera (fig. 19). Designed by Ron Spencer, this is a cute and cuddly stuffed animal that pays homage to its origins in Greek mythology by sporting the head of a lion, the body of a goat, and the tail of a serpent.

Although Wells's narrative is steeped in confabulation, the questions it posed linger today. Research scientist Evan Balaban's unique experiments with transplanted brain cells intensify debates concerning species integration and the transference of complex behaviors between differing species. In experiments akin to the fictive Moreau's, Balaban physically transplanted neural tissue from Japanese quail embryos into the brains of two-day-old Plymouth Rock chickens. In a startling result, these chimeric chickens emitted vocal sounds particular to quail mutterings. In addition, they engaged in up-and-down head bob-

bing, a gestural mannerism exclusively associated with quails.[2]

In Aziz + Cucher's works *Chimera #1*, *Chimera #3*, and *Chimera #8* (1999; pls. 48–50), the artists create images evocative of fetishes and idols often seen in prehistoric and Cycladic art. Coming into existence through Photoshop software, their photographs speak to a sculptural iconography. Neither gendered nor possessing locomotive appendages, the forms in the images recall primitive cellular forms not unlike paramecia and amoebas. Viewers are prompted to ask, How are these specimens kept alive? To what origin do they belong? Organically contoured and pigmented as generic Caucasian flesh, could these entities, in fact, be tissue-cultured in the biolab?[3]

Other questions posed by these photographs concern the viability of making organic spare parts for human use. By employing such novel technologies as bioprinting, it is currently possible to create some replacement tissues. Dr. Gabor Forgacs, a biophysicist, "used the bioprinter to deposit chicken heart cells onto a dish, [where] they started to beat synchronously."[4] And Dr. Anthony Atala printed bladders for young children as the first "laboratory-grown organs ever used in human trials"[5] (fig. 20). Even as artificial life-extension devices and tools made of flesh and blood appear in science-fiction films such as *Repo Men* (2010) and *eXistenZ* (1999), the conjoining of fantasy with reality continues on a most spectacular scientific level. And it is within this vein of thinking that Aziz + Cucher's photographs reveal a speculative optimism about the possibilities of human tissue regeneration.

In contemporary art, the work of Patricia Piccinini and Kate Clark addresses the question of the humanoid "animal," like that portrayed in Wells's *Dr. Moreau*. At once empathetic and monstrous, their sculptures confront the viewer with a variety of bioethical and philosophical questions. Both artists work in highly figurative styles, employing hyper-illusionism as a form of realism. Piccinini's lifelike sculptures depict animal-like creatures that exhibit human characteristics. In *Big Mother* (2005; pl. 56), a furless creature

stands erect as she suckles a human infant. Composed of silicone, fiberglass, human hair, and a diaper, the lifesize organism is at once human and simian, complete with an ape's leathery rump. As in Aldous Huxley's novel *Ape and Essence* (1948) or Franz Kafka's *A Report to the Academy* (1919), questions concerning climbing the evolutionary ladder abound. In all of these portrayals, apes sport a double identity, at once steeped in the animal kingdom and participants in the human world. Has Piccinini arrived at a vision of the "missing link"? Recalling nineteenth-century laws concerning miscegenation, in which the mixing of races was prohibited, Piccinini's *Big Mother* prompts moral questions in terms of animal-human hybrids and the role these in-betweens play in a techno-scientific democratic society. What social practices, labor laws, and racial politics do these sculptures point to? How human must a sentient creature be in order to be given human rights under the law?

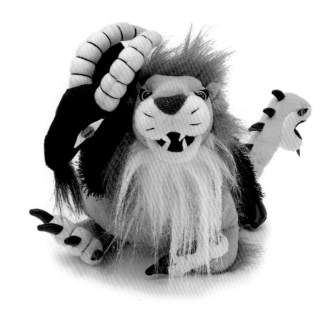

Figure 19. Chimera Plush. Courtesy of Toy Vault, Inc.

In *Still Life with Stem Cells* (2002; pl. 55), a young girl is seated on the floor playing with her toys. Unlike off-the-shelf figurines and dolls, these toys are cellular, fleshy blobs of matter. The artist refers to these entities as stem cells. The new stars in the lexicon of cell types, stem cells are pluripotent—that is, they are raw cellular material with the capacity to morph into numerous other types of cells, such as muscle, nerve, and skin cells.

The hyperrealistic style of the sculptures recalls the exactitude of Madame Tussaud's wax museum, in which lifelike body doubles are at once arresting and uncanny. However, like Alice in Wonderland's encounters with topsy-turvy scale, the viewer is presented with microscopic stem cells in gargantuan proportion. Like the creatures in Ridley Scott's *Alien* (1979) and Steven Spielberg's *E.T.* (1982) and *A.I.* (2001), Piccinini's creations are futuristic technobots, acting out would-be dramas of a genetically altered world.

Figure 20. Artificial bladder in a beaker, grown by a team led by Dr. Atala of Harvard Medical School.

For Kate Clark, fur is a signature icon. From zebra skin to bear fur to deer hides, the taxidermied exteriors are coupled with human faces. Although the faces are stitched together in a rough-hewn manner, the creatures' eyes glare mournfully. The emotion-

ally charged wolf couple in *Bully* (2010; pl. 18) is, as in Mary Shelley's vision, simultaneously pathetic, endearing, and threatening. As in film versions of Dr. Frankenstein's monster, external sutures in *Bully* speak to a piecing together, an after-the-fact reconstitution. Revamping the extant, or transforming existing matter through recycling, also reassigns gender roles in this work. The female Canadian wolf stands erect and in control, while her male counterpart cowers in passive pose. Poised as an interruption in instinctively hierarchical power practices within the wolf pack, the elasticity of dominant sexual roles is portrayed as a gender reversal of vulnerability. Can instinctual animal response, in fact, be recoded? As in Balaban's chicken-quail experiments, the answer is a resounding yes.

Nineteenth-Century Reconfiguration and the Natural World

Mary, Mary, Fairy, Fairy, how does your garden grow?
From pure pipettes with no regrets, with green bunny
 rabbits aglow.
Mary, Mary, Fairy, Fairy, how does your torso grow?
From a splice here, to add an ear, and ova in the flow.

The nineteenth century produced such visionaries as Mary Shelley, Gregor Mendel, Ernst Haeckel, Thomas Huxley, and Charles Darwin, whose startling narratives, hypotheses, and conjectures embracing the natural world and its living properties inspired enormous reconfigurations and continue to maintain their grip on the twenty-first century's imagination. As their works entered public discourse, these thinkers spurred the notion of science as a secularizing force in society. Invention, intervention, and notions of progress have been seen as competition to religious dogma. At the same time, a modernist stance on chance, adaptation, and human agency came to the fore. How is life created? What accounts for its hereditary linkages? How are we related to other living creatures?

As noted by literary scholar George Levine,

"Darwin's theory thrust the human into nature and time, and subjected it to the same dispassionate and material investigations hitherto reserved for rocks and stars. His history of the development of species gave authoritative form to a new narrative—or set of narratives—that has permanently reshaped the Western imagination."[6] The notion that life itself, in all its complex mechanisms, could, in fact, be unraveled into systematic laws was reshaped once again in the twentieth century by Watson and Crick's discovery of DNA's structure. In 2000, the initial draft of the human genome was made public, triggering artistic and scientific imaginations. A host of exhibitions, conferences, texts, and films incorporating metaphors and narratives connected to DNA's discursive power infiltrated the cultural landscape. Within the scientific corporate culture, biotech companies fiercely competed for patents on gene sequences, pharmaceuticals, and even seeds. Biomatter was the new resource to be explored, colonized, and mined.

The rise of genetic engineering, PGD technologies, and tissue culturing allows for the creation of "mix and match" species—and with that, the highly controversial patenting of life forms.[7] What was once considered abject has now become raw material for new life, leading to such developments as the biobanking of cord blood garnered from umbilical cords and the production of Oncomouse and other lab-born animals, cybrids, and neo-morts.[8] Thus the rise of biotech, as a major corporate enterprise, is speeding up the processes of evolution itself. Time is being repackaged and sold back to the highest bidder in the form of procured organs, nips and tucks, and biolicensing agreements. At a time when what it means to be human is undergoing radical bioethical consideration, the cross-species sagas demand a sustained and careful analysis.

Marvels take myriad forms: transformations, anomalies, and magical rites. In fairy tales (and cartoons) the protagonists have special powers, such as animals that can talk and reason, creatures with exaggerated or diminished bodily configurations, or

even entities that can combine attributes belonging to another class of species. Aristotle, through his investigation into the nature of animals, talks about their bodily attributes as being a constituent of their material cause.[9] What are the consequences of constituent material causes being interrupted or even debased? While fanciful in imaginative play or the arts, the brooding underside of mixing life forms has yet to be determined.

Flesh as a Mix-and-Match Code

Conception taking place in test tubes, nuclear transfers in petri dishes, embryos that have been cryogenically stored like so much frozen food—these are some of the high-tech ways that reproduction has expanded far beyond the old carnal way of making babies. Wombs can be rented out through surrogacy contracts, and children can be genetically related to three parents. When virgins can give birth and corpses can be fathers, what's next? When posed with the classic children's query "Where do babies come from?" will the answer soon include the biolab? Will the bundle-carrying stork, which has figured in myriad fairy tales from Hans Christian Andersen to a more recent cameo in Dr. Seuss's *How the Grinch Stole Christmas* (1957), be finally exiled from our mythology surrounding birth? If the stork is no longer employed as a stand-in shielding children from the knowledge of sex, how should assisted reproductive technology (endearingly known as ART) be personified? Will a host of twenty-first-century fairy tales emerge to dramatize asexual reproduction? Will such avatars appear robotic or in full laboratory regalia? Will these narratives embrace the magical or religious? Recently in the United Kingdom, birth certificates have also come under review as legal documents of parentage as assisted reproduction technologies have created alternative family structures.[10]

Genetic manipulations, tissue engineering, and the bioprinting of organs add to the methods in which fabricated fantasy meets hard-core reality. Many artists have explored this terrain, and the number of exhibitions, texts, and conferences continue to expand. Visual artists have pictured various social scenarios brought about by these changes in the material world. At once hyperbolic and yet "nonfiction," art encounters science in the cultural imaginary.

Global Degrees of Difference: The Bio-mashup or Taxogenomic Crash

Mary, Mary, Fairy, Fairy, how does your garden know?
From super cells to mystery gels all bound up in roe.
Mary, Mary, Fairy, Fairy, how does your water flow?
From silver sloths to tasty broth as ointments in the know.
Mary, Mary, Fairy, Fairy, why are you so merry?
With pharma-pigs and hundreds of gigs, upon a pile of cherries.
Mary, Mary, Fairy, Fairy, why is your garden so green?
With fruit of the loom and all its doom, and tasty puddings of spleen.

Drawing on surrealism's complex and rich image bank, Janaina Tschäpe's work is also an invocation of the fanciful chimera. Her work focuses on the fecundity of nature, in which enhancement and growth come together in an excessively aggressive sprouting. The lush garden of Edenic paradise is presented in tropical renditions, steeped in the effervescent multiplication of fructified and gnawing forms. In Tschäpe's world any combination is possible. The artist describes her relationship to the chimera: "What makes the Chimera a fearful monster isn't any of its traits in particular, but the fact that they are all combined in a single being."[11] She draws a parallel of this being to her working process. She sees her art production as an amalgamation of elements operating in painting, photography, film, and performance.

In Tschäpe's series *Melantropics*, verdant greens, bulbous forms, and hairy spiders converge on a pictured body, leaving only a small portion of flesh to be

observed. In this oceanic abyss of surrealistic notation, one is reminded of nature's repetitive yet unique strategies. Seedlike, podlike constructed sculptures establish the basis of her tableaux, and in this world inhabitants are out of scale. Such fabrications of the mind move us into the terrain of the unconscious where every possibility can exist simultaneously. Overtly and voraciously feminine, her objects also possess delicacy, making them less frightening. When Alice was in Wonderland, she too experienced the body phenomenon of being out of scale. *Melantropics*, produced during a residency at the Missouri Botanical Gardens in St. Louis in 2005–2006 (pls. 60–61), combines fabrics, vegetal forms, and bulbous balloons to further augment nature's ferocious fecundity.

Tschäpe, although born in Germany, has spent much time in Rio de Janeiro. As the offspring of a German father and South American mother, she was exposed to a rich botanical and cultural environment, and its impact is traced out in her work. Darwin, in his 1832 voyage on the *Beagle*, commented on the landscape of Rio and the tropical rainforest: "It was impossible to wish for any thing more delightful than thus to spend some weeks in so magnificent a country. In England any person fond of natural history enjoys in his walks a great advantage, by always having something to attract his attention; but in these fertile climates, teeming with life, the attractions are so numerous, that he is scarcely able to walk at all."[12]

In all forests, enchantment and danger are entwined and ever present. From poisonous plants and snakes to flamboyant flowers, the rainforest in particular is a transformative place of wonder and biodiversity. Its impact extends far beyond its own boundaries, producing 40 percent of Earth's oxygen, a breath of life for all sentient creatures. The point brought home by the ethereality of Tschäpe's figures is that the biodiversity of the tropical rainforest, especially in Brazil's Amazon Basin, is under assault from deforestation and pollution. Perhaps one day we will ask,

> *Mary, Mary, Fairy, Fairy,*
> *where have all the forests gone?*

> *One by one and ton by ton*
> *The creatures are a-dying.*
> *We sit and stare as they lay bare*
> *With greed and need, and all to feed.*
> *Why are we not crying?*

Saya Woolfalk's work as well hearkens toward a world of fantasy in which evolution is out of sync with Darwinian principles. As an artist of mixed descent—African American, Caucasian, and Japanese—she too has a culturally rich vocabulary of resources to draw from. Her fantastic creatures, part plant, part animal, live in No Place, an ironic twist on Thomas More's Utopia (pls. 70–71). Woolfalk writes that "No Placeans are not particular plants," and that she "would be happy to see them evolve into other kinds of creatures." Her No Placeans represent an apex of mutability, a transformative principle in systems of change and growth. In her fictional world, the No Placeans "can change color and gender, have kinship rituals and dissolve back in the landscape when they die."[13]

Resonating with popular culture and urban debris, the biological world becomes a conceptual matrix with underlying concepts such as life, death, community, gender, and politics. Woolfalk's fanciful plant-human hybrids speak to a world that is mutable and magical. The discrete unity we associate with life forms is brought into a colliding world of ultimate morphing, a carousel of would-be identities and amorphous borders. Spinning in a world of atemporality, where past and present intersect into one, Woolfalk's mantra is one of metamorphosis.

But, as nature would have it, we are reminded of Darwin's tangled bank at the conclusion of *The Origin of Species*: "Whilst this planet has gone cycling on according to the fixed law of gravity, from so simple a beginning endless forms most beautiful and most wonderful have been, and are being evolved."[14] Ironically, Tschäpe's and Woolfalk's visions of interspecies mutations are not beyond the capacity of nature to achieve, with or without the assistance of genetic technology. This is shown in the example of the green sea slug, *Elysia chlorotica*, which has the uncanny ability

to photosynthetically produce food. Employing genes stolen from algae, this creature is a solar-powered chlorophyll-manufacturing hybrid.[15] As scientist John Zardus has noted, "This could be a fusion of a plant and an animal—that's just cool."[16]

Motohiko Odani's video *Rompers* (2003; pl. 68) examines a lush world of elaborate fauna, where an animated existence veils a more foreboding warning. In his camouflaged paradise, aspects of his characters do not conform to external reality. A young woman with pale chartreuse eyes stares out at the viewer as if in a trance. Her enchanting girlish pose takes a more grotesque turn when she reveals her chameleon tongue. Against a landscape of emerald-green water, oozing amber sap, and frolicking frogs with human ears on their backs, the heroine blissfully chants *oo-la-la-le, oo-la-la-le*, over and over again. In such an Edenic setting, nature's secrets, carefully guarded, become the material out of which mutants are made.

Odani's hybridized frogs also make reference to Dr. Joseph Vacanti's famous, yet failed, experiment in which the surgeon-scientist attached the substrate of a human ear onto the back of a mouse (fig. 21). The image of the mouse has become an icon, and has appeared in various forms ranging from apparel (such as T-shirts and bags) to Alexis Rockman's painting *The Farm* (2000) to an episode of the popular TV series *CSI*.[17]

Figure 21. Vacanti mouse. Joseph P. Vacanti, M.D., Massachusetts General Hospital, 2011.

and distraught facial expression reflect his feeling of being a perpetual outsider, one who, like many popular culture misfits, yearns to be loved.

As genetic theories, neurobiological data, and cognitive psychology set the standards for the new "normal," how does one express infantile repression and its transgression? How do our animal natures reveal us? The psychology of the social, the outcast, the other, the pathological body, reminds us of the primitive within us. Just as it does in White's tableaux, the cruelty expressed in many fairy tales elucidates just how much fear we harbor and what underlying psychological distress is beyond our reach and grasp. Should the pathological body be enhanced? Should disability be eliminated? What is the new normal? What are adequate indicators for a psycho-pharmacological fix? What is the Darwinian imperative for cruelty, misery, and dystopia?

Sexual Encounters and Creature Discomfort

In Charlie White's series of photographs titled *Understanding Joshua* (2001), the artist creates a male persona infected by hyper-anxiety. As a displaced stand-in for social awkwardness, Joshua is thrust into settings which exasperate his already fragile ego. In *Cocktail Party* (pl. 58), the bizarrely proportioned Joshua—who could be a visitor from another planet or the result of a laboratory experiment gone awry—is attending the event buck naked. Surrounded by beautiful people, colorfully clad, his pathetic appearance

Darwinian Imperatives

Charles Kingsley, a nineteenth-century Anglican theologian and friend of Darwin's, believed that "moral lessons of nature" could be taught through his delight-

ful fairy tale "The Water Babies." In this parable, which was read aloud to children in Victorian England, a young chimney sweep, Tom, appears filthy and uncouth, a clear indication of his lowly social status. In an effort to escape his master and others running after him, he falls into a stream, where he descends into a deep sleep. Here he meets up with fairies, who transform him into a water baby. In this state he acquires a set of gills. As he learns through reason and judgment to accomplish the tasks before him, he continues to change. Each time he performs his cerebral tasks, he moves up the phylogenetic order, from fish to amphibian to mammal.

In an effort to reconcile Darwin's theory of evolution with Christian theology, Kingsley sets up a dialogue between Tom and one of the chief fairies, Mother Carey:

> "I hear you are very busy."
> "I am never more busy than I am now," she said without stirring a finger.
> "I heard ma'am, that you were always making new beasts out of old."
> "So people fancy. But I am not going to trouble myself to make things, my little dear. I sit here and make them make themselves."[18]

Ironically, Mother Carey's words not only resonate with Darwin's tangled bank of endless forms, but also presage current scientific experiments, particularly with glowing green monkeys. As Maggie Fox of Reuters reported in 2009, "Japanese researchers have genetically engineered monkeys whose hair roots, skin and blood glow green under a special light, and who have passed on their traits to their offspring, the first time this has been achieved in a primate." What is important in this experiment is that "green-glowing monkeys have green-glowing babies."[19] As Mother Carey states, "I sit here and make them make themselves."

My own work, *Water Babies* (2004–2006; pl. 51), takes its title from Kingsley's parable. In this photographic set viewers are confronted with fetuses submerged in preservation liquids, just as Tom was submerged in the waters of the stream, from which he followed an evolutionary trajectory toward full humanhood. These photographs, however, are not of imagined creatures, but are actually taken in museums and laboratories. They appear to occupy zones of ambiguity, with bodies and their parts floating anonymously as mementos marking historical time. Provoking questions concerning the dualities of death and life, these raw tissues reveal emotive states of consciousness. What questions are provoked by once-living matter enclosed in a glass veil? To go behind a veil is to transgress a hidden boundary. At the same time the veil becomes a mirror for our concealed selves, as we peek behind the curtain of inscrutable worlds. Although real, these preserved specimens partake of the fictive, engaging their formal presence as cultural and historical artifacts. Occupying a world of unimaginable repose, the fetus is a primal marvel. A mystery in itself, it has come to represent life as a continuous cycle, moving from birth to death, or like Tom, moving from being a primitive gilled organism to one that is fully sentient and aware.

Conclusion

In this essay, I have chosen to compare works of art in the exhibition to advances in biotechnological sciences. An analysis of the artwork from a formal or historical point of view is a topic for another essay. From a socially critical point of view, how do we assess the images portrayed within this exhibition? Is it adequate to invoke the chimera, the animal, or the natural world to render such image content valid? What responsibility does the human animal possess with regard to other sentient creatures? The chimera is a complex entity that is more than an amalgam of diverse parts or an adhesion through substitution. It is a thorough reworking of the ontological status of the finite. It is a collapse of the whole in favor of its parts.

The great American pragmatist John Dewey's seminal text *Art as Experience* (1934) conceives of experiencing art as a civilizing cultural process akin to developing moral judgment. Going beyond its material significance, art becomes a communicating vehicle in which objects (and images) talk back. Much of Dewey's moral philosophy was necessitated by the shifts in living styles generated by the accelerating demands of new urban life. Yet developing moral judgments in a technoscientific society remains another task.

In this disjunctive, transgressive time, a dismantling of values continues to summon the adaptation of alternative ones. What is marvelous in visual art may be treacherous in science, and vice versa. While the chimera may be humorous or endearing or scary in art, what may it be in science? Advances in biomedicine surely rely on its manufacture as living models to combat disease. In *The Future of Human Nature*, Jürgen Habermas calls for a "species ethics": "The advance of the biological sciences and development of biotechnologies at the threshold of the new century do not just expand familiar possibilities of action, they enable a new type of intervention. What hitherto was 'given' as organic nature, and could at most be bred, now shifts to the realm of artifacts and their production."[20]

Mary, Mary, Fairies, Fairies, I bid you sweet farewell.
Until that time, there is no wine,
I'll stay the course, of course.
With wondrous wimps and naked chimps,
 we'll meet again to tell.
Mary, Mary, Fairy, Fairy, why are your maggots
 so haggard?
Return to earth another birth, all clean and neatly
 lathered.

Notes

1. For further reading, see David K. C. Cooper and Robert P. Lanza, *Xeno: The Promise of Transplanting Animal Organs into Humans* (New York: Oxford University Press, 2000).

2. Evan Balaban, "Brain Switching: Studying Evolutionary Behavioral Changes in the Context of Individual Brain Development," *International Journal of Developmental Biology* 49 (2005): 117–24.

3. Both artists and scientists are employing live cells to create tissues. Artists are using tissue culturing as a medium in sculpture, and scientists are exploring possibilities in regenerative medicine. In such procedures scientists have the ability to use a patient's own healthy cells as replacement parts for diseased tissues. The process of reconfiguring inkjet printers to accommodate living cells is called bioprinting. See, for example, the SymbioticA lab (*www.symbiotica.uwa.edu.au/*), under the artistic direction of Oron Catts, and Mitchell Joachim's "In Vitro Meat Habitat" (*www.archinode.com/arch.html*).

4. Michael Anissimov, "What Is Bioprinting?," *WiseGeek*, last modified February 16, 2001, *www.wisegeek.com/what-is-bioprinting.htm*.

5. Christine Fall, "Calling All *Repo Men*: 3-D Bio-printing Creates a Market for Artificial Organs," *AMC Film Critic*, February 3, 2010, *www.filmcritic.com/features/2010/02/repo-men-artificial-organs/*.

6. George Levine, *Darwin and the Novelists: Patterns of Science in Victorian Fiction* (Chicago: University of Chicago Press, 1988), 1.

7. PGD is the acronym for preimplantation genetic diagnosis employed in embryo selection.

8. Oncomouse was developed at Harvard College by Dr. Philip Leder and Dr. Timothy A. Stewart and received a patent in 1988. Patents are usually reserved for nonliving entities, but are now also issued for transgenic botanicals and animals. Cybrids are the creation of human-animal hybrid embryos to be used for research purposes. See Olivia Johnson, "Enter, the Cybrids," *New York Times*, May 20, 2008. Neo-morts are humans who are brain dead but whose bodies continue to exhibit living features if hooked up to a machine. In essence a neo-mort is a "live" cadaver.

9. See Aristotle, *The History of Animals*, trans. D'Arcy Wentworth Thompson (published electronically by eBooks@Adelaide, 2007).

10. See Louisa Ghevaert, "Birth Certificates: A New Era," *BioNews* 556 (April 30, 2010), *www.bionews.org.uk*.

11. Quoted in a press release for *Janaina Tschäpe: Chimera*, Irish Museum of Modern Art, 2008.

12. Charles Darwin, *Narrative of the Surveying Voyages of His Majesty's Ships Adventure and Beagle between the years 1826 and 1836*, vol. 3 (London: Henry Colburn, 1839; repr., New York: AMS Press, 1966), 29.

13. E-mail correspondence with Saya Woolfalk, August 2, 2010.

14. Charles Darwin, *The Origin of Species* (1859), chap. 14, *www.literature.org/authors/darwin-charles/the-origin-of-species/chapter-14.html*.

15. Catherine Brahic, "Solar-Powered Sea-Slug Harnesses Stolen Plant Genes," *New Scientist*, November 24, 2008.

16. Quoted in Susan Milius, "Green Sea Slug Is Part Animal, Part Plant," *Science News*, January 11, 2011.

17. See, for example, the T-shirt design by Amorphia Apparel at *amorphia-apparel.com/design/earmouse*.

18. Charles Kingsley, *Water Babies: A Fairy Tale for a Land Baby* (London: Macmillan, 1917). For further analysis, see John Beatty and Piers J. Hale, "Water Babies: An Evolutionary Parable," *Endeavor* 32, no. 4 (November 7, 2008): 145.

19. Maggie Fox, "Green-Glowing Monkeys Have Green-Glowing Babies," *Reuters*, May 27, 2009.

20. Jürgen Habermas, *The Future of Human Nature* (Cambridge: Polity Press, 2003), 38–39.

Additional Sources

Anker, Suzanne, and Nelkin, Dorothy. *The Molecular Gaze: Art in the Genetic Age*. Cold Spring Harbor, NY: Cold Spring Harbor Laboratory Press, 2004.

Beer, Gillian. *Darwin's Plots: Evolutionary Narrative in Darwin, George Eliot and Nineteenth-Century Fiction*. 3rd ed. Cambridge: Cambridge University Press, 2009.

Bettelheim, Bruno. *The Uses of Enchantment: The Meaning and Importance of Fairy Tales*. New York: Vintage Books, 2010.

Cashdan, Sheldon. *The Witch Must Die: Hidden Meaning of Fairy Tales*. New York: Basic Books, 1999.

Franklin, Sarah. *Dolly Mixtures: The Remaking of Genealogy*. Durham, NC: Duke University Press, 2007.

Jones, Steven Swann. *The Fairy Tale: The Magic Mirror of the Imagination*. New York: Routledge, 2002.

Lennox, James, trans. *Aristotle: On the Parts of Animals*. Oxford, UK: Clarendon Press, 2001.

Morgan, Lynn M. *Icons of Life: A Cultural History of Human Embryos*. Berkeley: University of California Press, 2009.

Pauwels, Luc, ed. *Visual Cultures of Science: Rethinking Representational Practices in Knowledge Building and Science Communication*. Hanover, NH: Dartmouth College Press, 2006.

Sharp, Lesley A. *Strange Harvest: Organ Transplants, Denatured Bodies and the Transformed Self*. Berkeley: University of California Press, 2006.

Sumpter, Caroline. *The Victorian Press and the Fairytale*. Basingstoke, UK: Palgrave Macmillan, 2008.

PLATES

Plate 1
Amy Stein
Predator, 2006

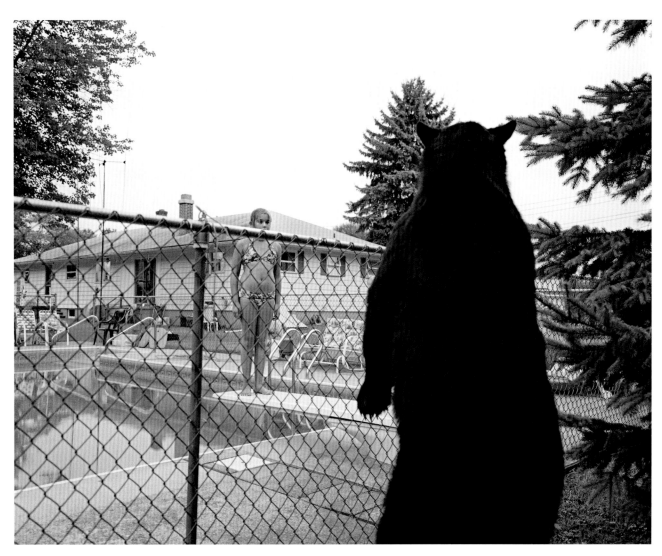

Plate 2
Amy Stein
Watering Hole, 2005

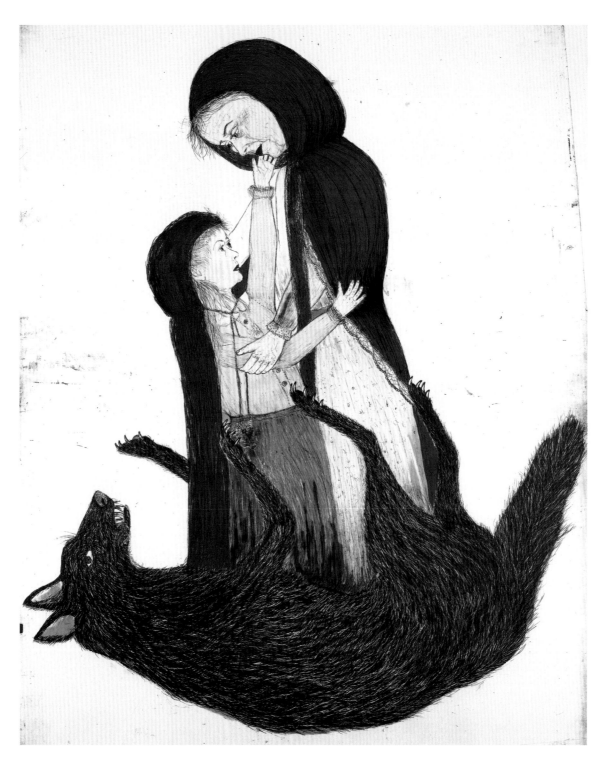

Plate 3
Kiki Smith
Born, 2002

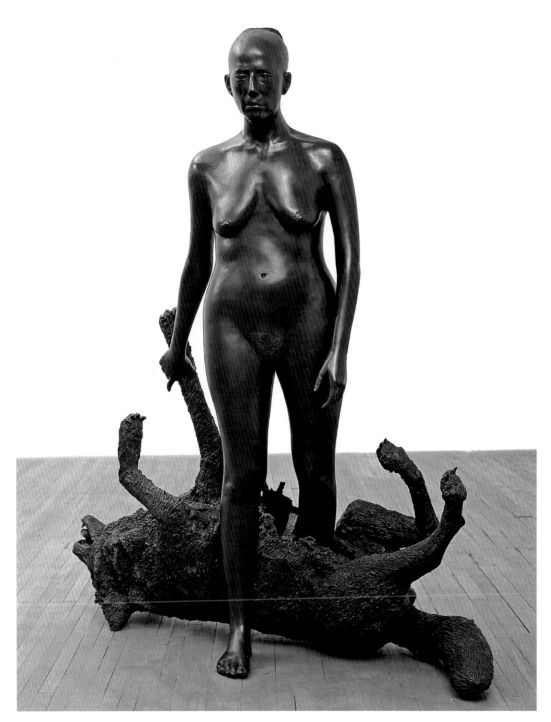

Plate 4
Kiki Smith
Rapture, 2001

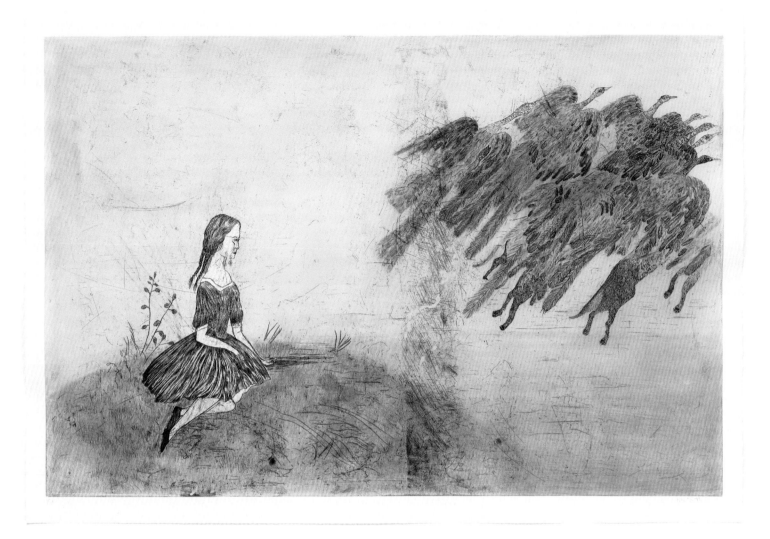

Plate 5
Kiki Smith
Come Away from Her (after Lewis Carroll), 2003

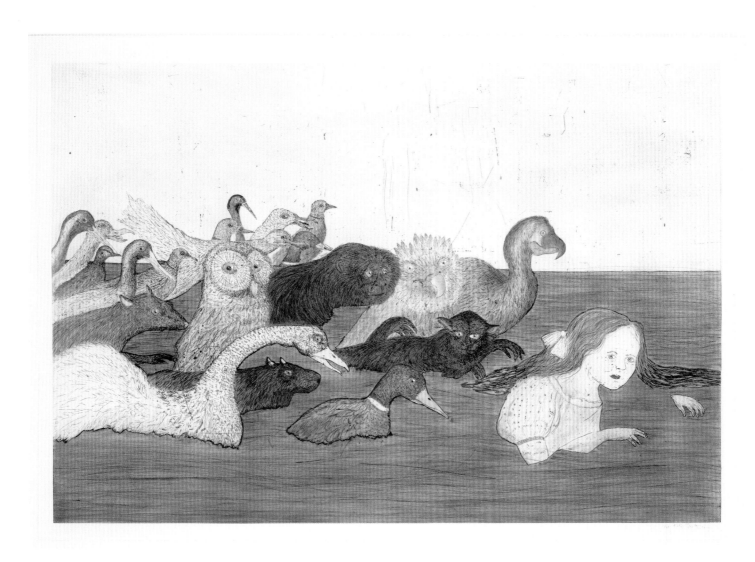

Plate 6
Kiki Smith
Pool of Tears 2 (after Lewis Carroll), 2000

Plate 7
Paula Rego
Peter Pan: The Never Land, 1992

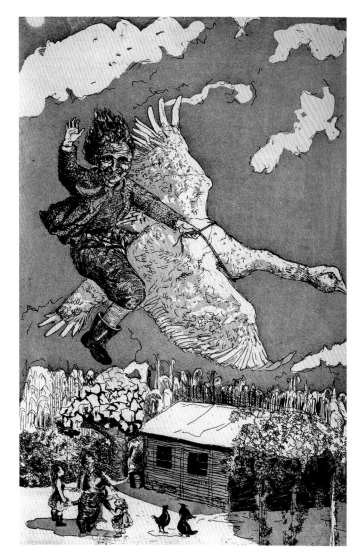

Plate 8
Paula Rego
Nursery Rhymes: Old Mother Goose, 1989

Plate 9

Paula Rego

Nursery Rhymes: Who Killed Cock Robin I, 1989

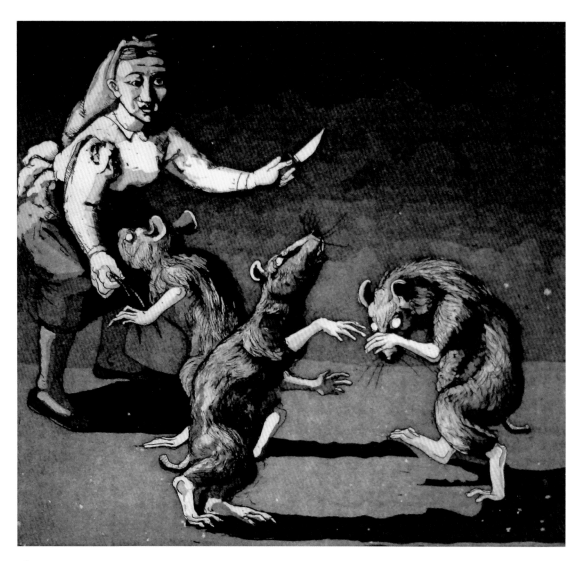

Plate 10
Paula Rego
Nursery Rhymes: Three Blind Mice II, 1989

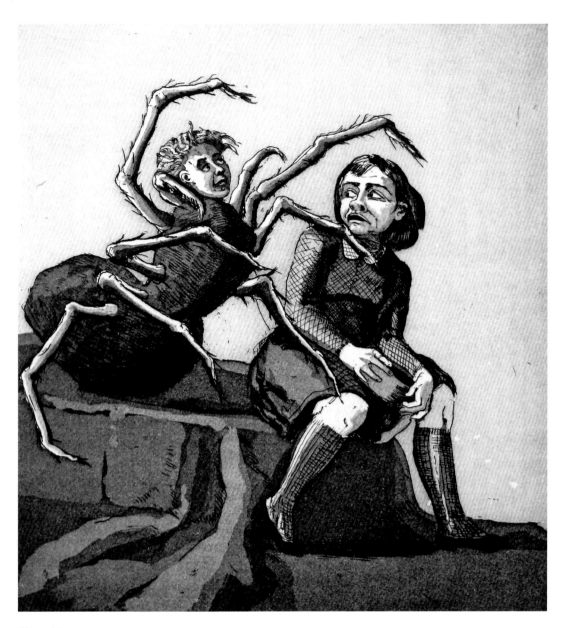

Plate 11
Paula Rego
Nursery Rhymes: Little Miss Muffett III, 1989

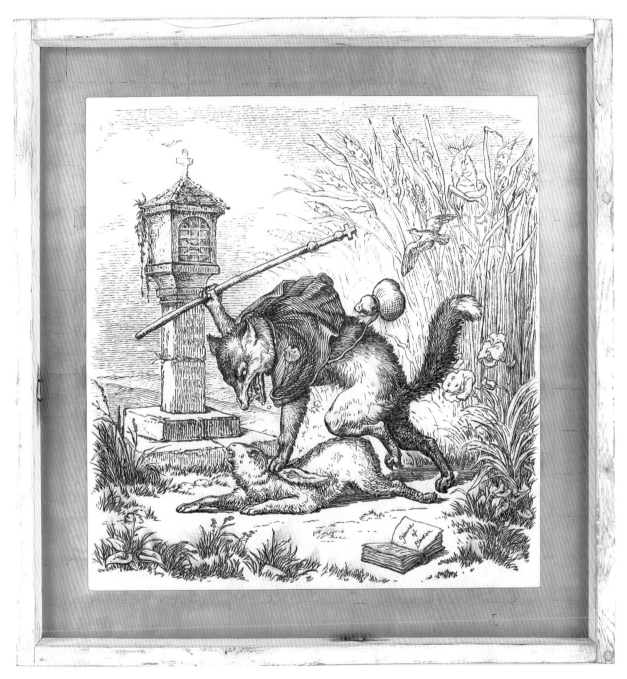

Plate 12
Tom Sachs
Hours of Devotion, 2008

Plate 13
Marcel Dzama
La verdad está muerta / Room Full of Liars, 2007

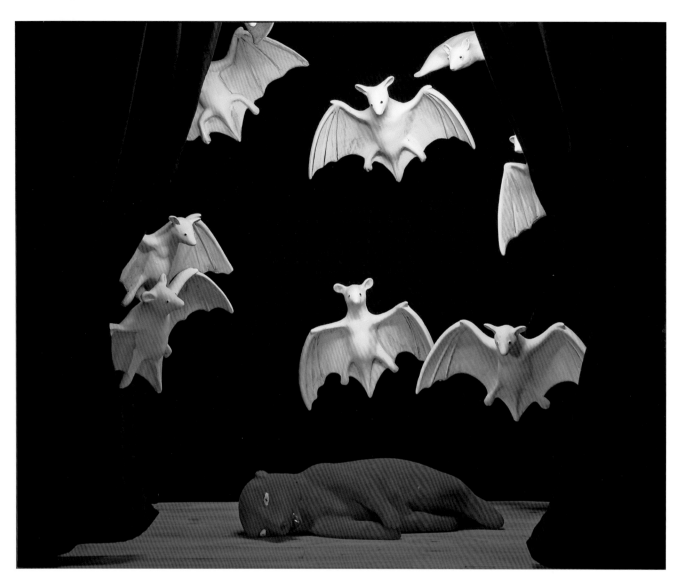

Plate 14
Marcel Dzama
Welcome to the Land of the Bat, 2008

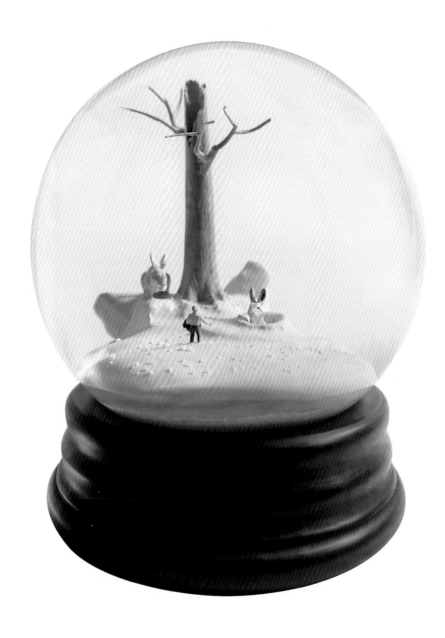

Plate 15
Walter Martin and Paloma Muñoz
Traveler CCXXVIII, 2007

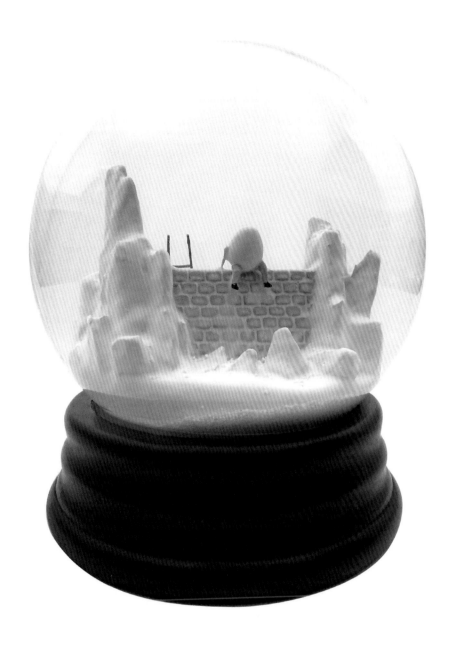

Plate 16
Walter Martin and Paloma Muñoz
Traveler CLXXXVI, 2006

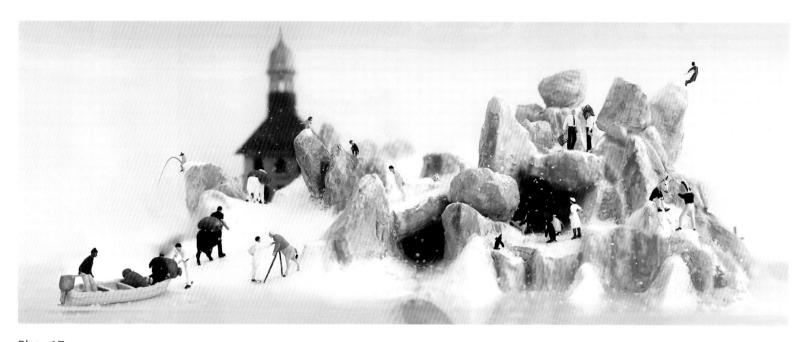

Plate 17
Walter Martin and Paloma Muñoz
The Mail Boat, 2007

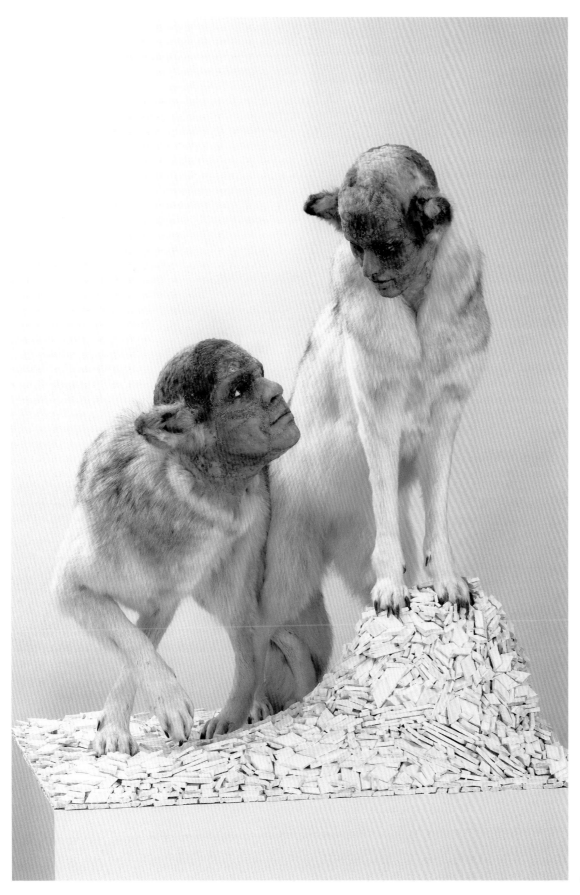

Plate 18
Kate Clark
Bully, 2010

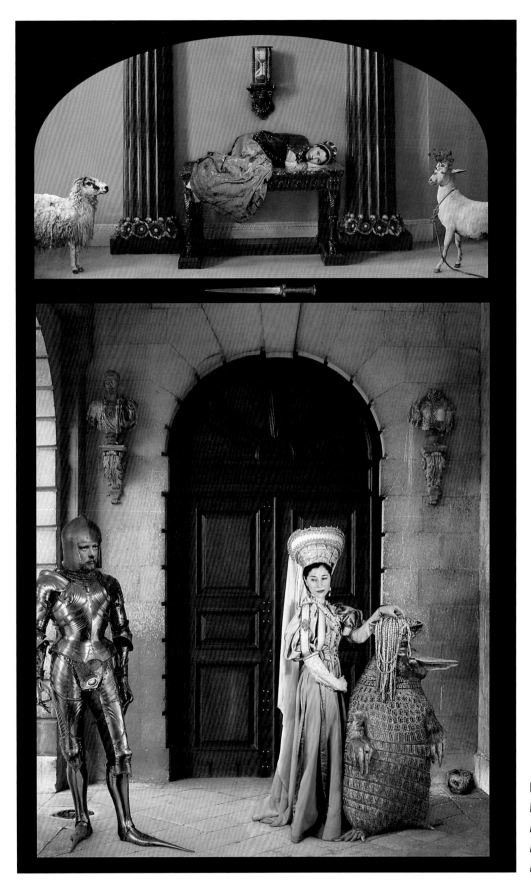

Plate 19
Meghan Boody
Henry's Wives: Katheryne Howard: "No Other Wish but His," 1997

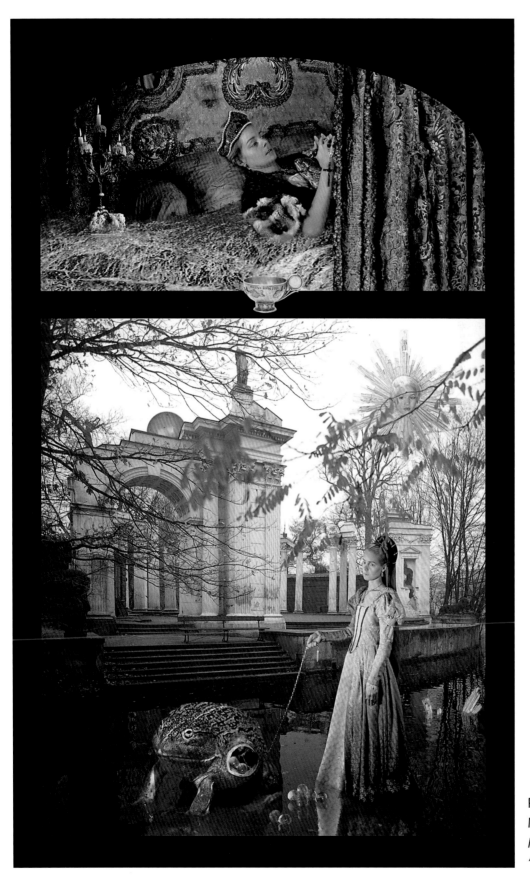

Plate 20
Meghan Boody
Henry's Wives: Jane Seymour:
"Bound to Obey and Serve," 1997

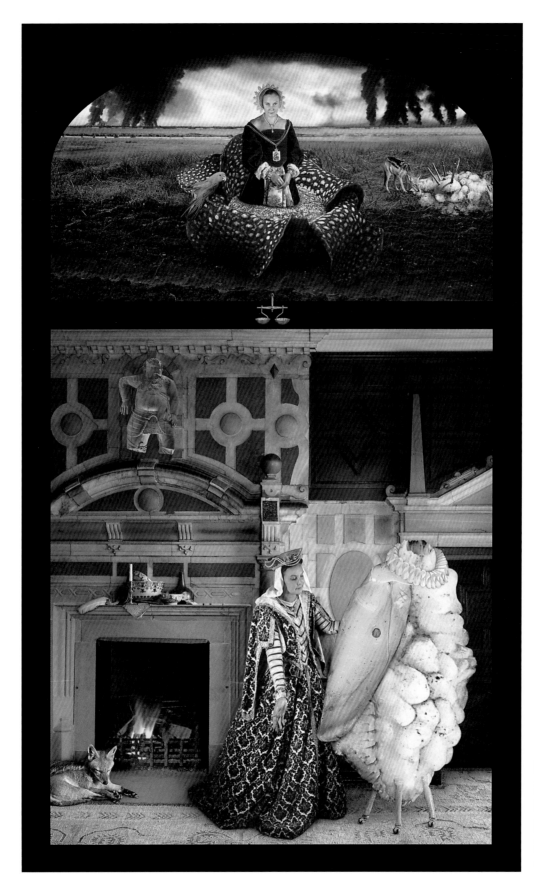

Plate 21
Meghan Boody
Henry's Wives:
Katherine Parr: "To
Be Useful in All I Do,"
1997

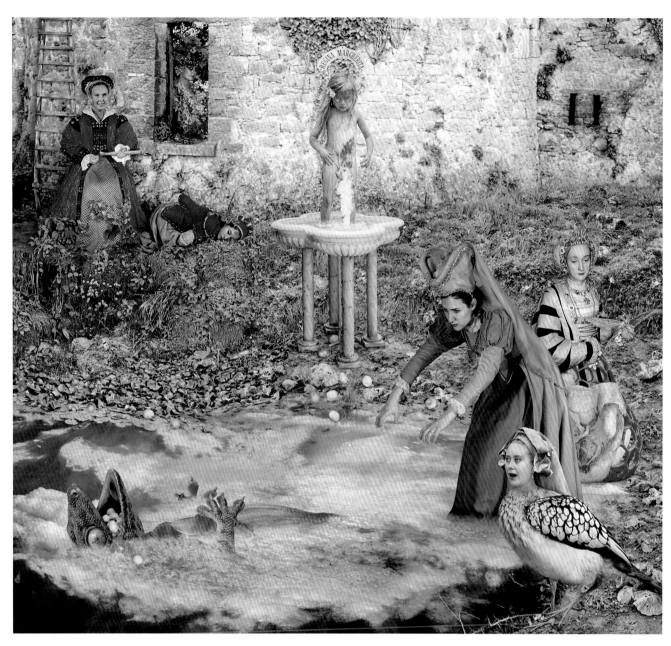

Plate 22
Meghan Boody
Henry's Wives: In a Garden So Greene, 1998

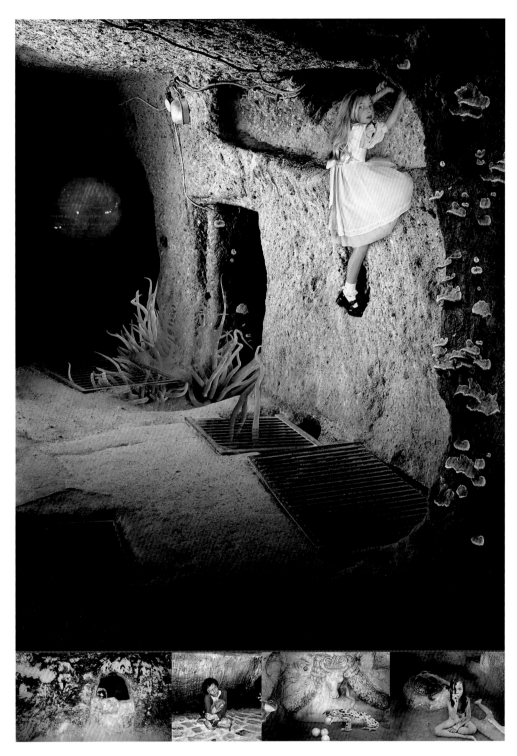

Plate 23
Meghan Boody
Psyche and Smut: Psyche Enters, 2000

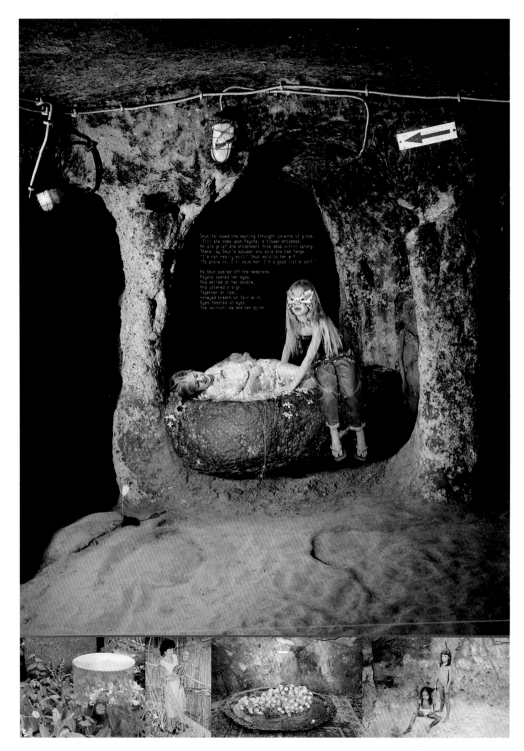

Plate 24
Meghan Boody
Psyche and Smut: Psyche Wakes, 2000

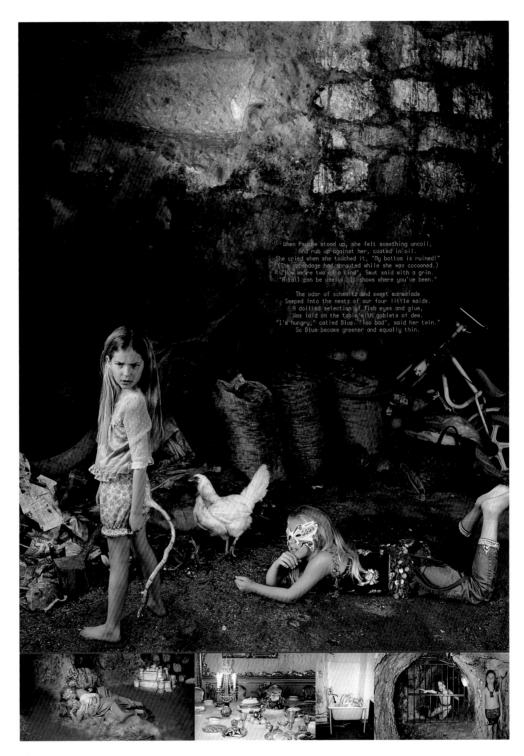

Plate 25
Meghan Boody
Psyche and Smut: Psyche's Tail, 2000

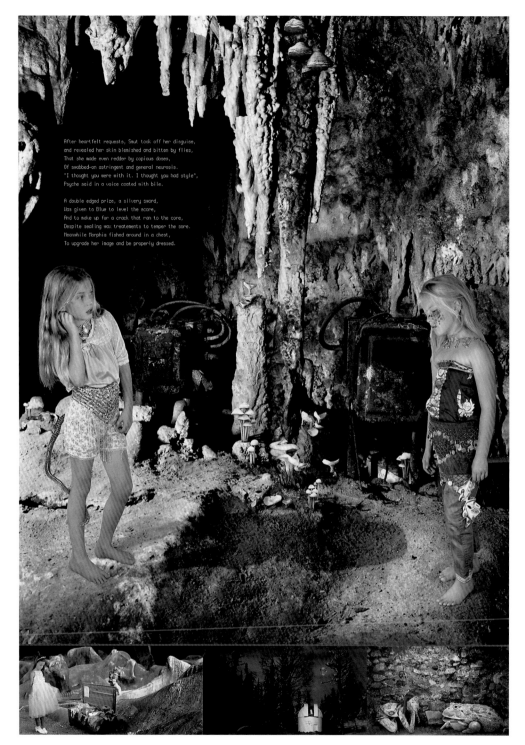

After heartfelt requests, Smut took off her disguise,
and revealed her skin blemished and bitten by flies,
That she made even redder by copious doses,
Of swabbed-on astringent and general neurosis.
"I thought you were with it. I thought you had style",
Psyche said in a voice coated with bile.

A double edged prize, a silvery sword,
Was given to Blue to level the score,
And to make up for a crack that ran to the core,
Despite sealing wax treatments to temper the sore.
Meanwhile Morphia fished around in a chest,
To upgrade her image and be properly dressed.

Plate 26
Meghan Boody
Psyche and Smut: The Assessment of Smut, 2000

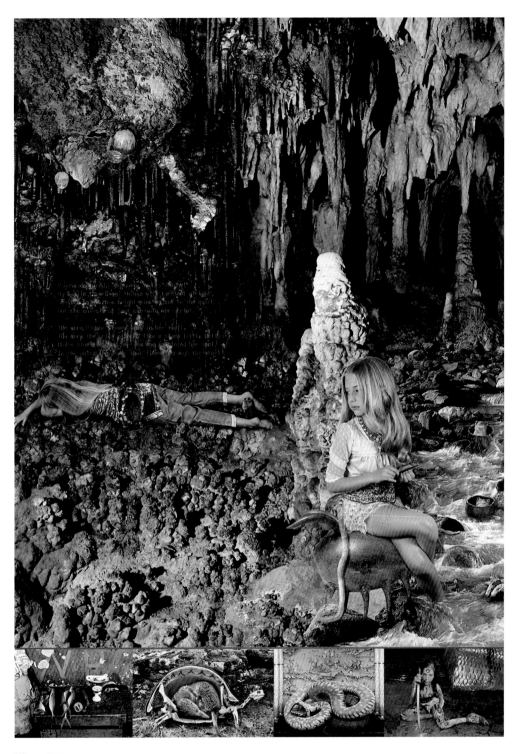

Plate 27
Meghan Boody
Psyche and Smut: The Snivels of Smut, 2000

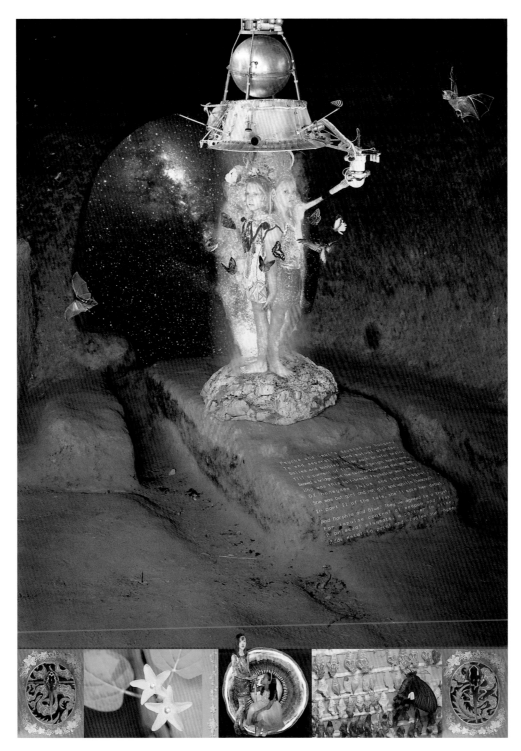

Plate 28
Meghan Boody
Psyche and Smut: Psyche Supernova, 2000

Plate 29
Mark Hosford
Haunting 3, 2008

Plate 30
Mark Hosford
Haunting 4, 2009

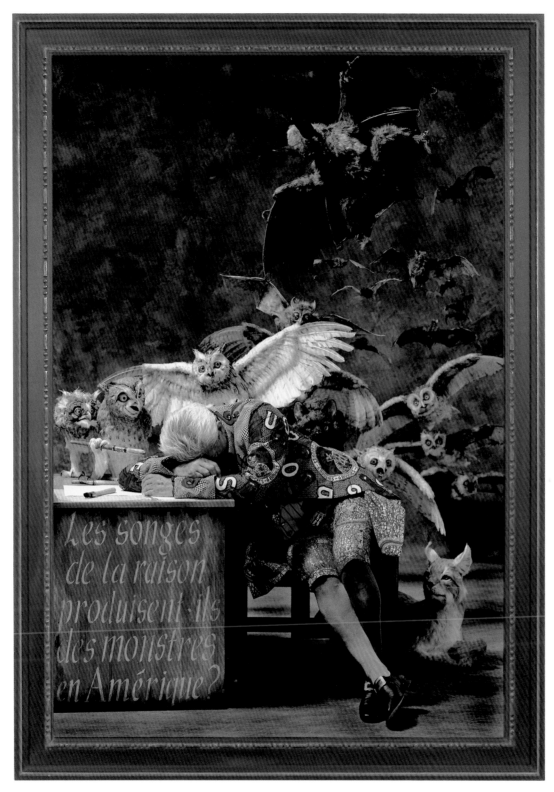

Plate 31
Yinka Shonibare, MBE
The Sleep of Reason Produces Monsters (America), 2008

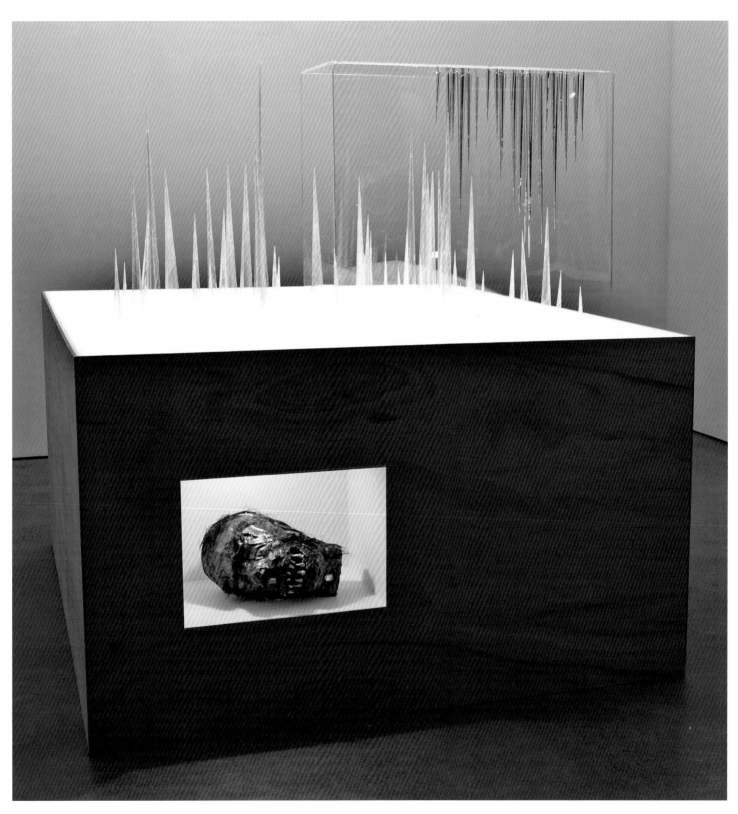

Plate 32
David Altmejd
Werewolf 1 (Loup-garou 1), 2000

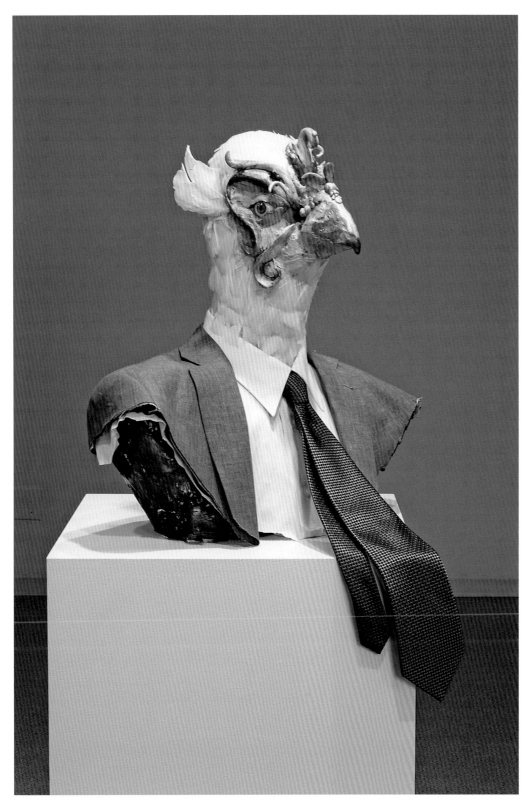

Plate 33
David Altmejd
Untitled (Man's Hard Idea Comes Out of His Head), 2007

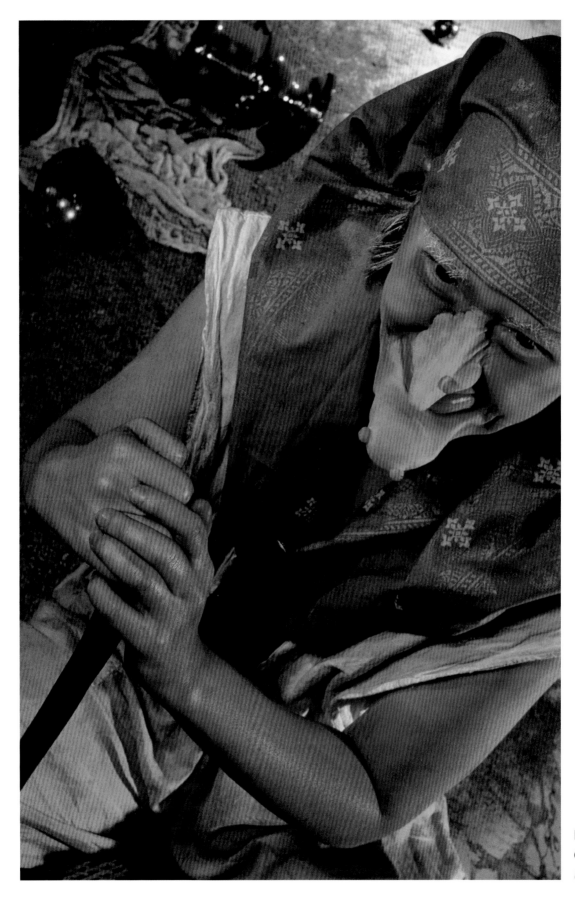

Plate 34
Cindy Sherman
Untitled #151, 1985

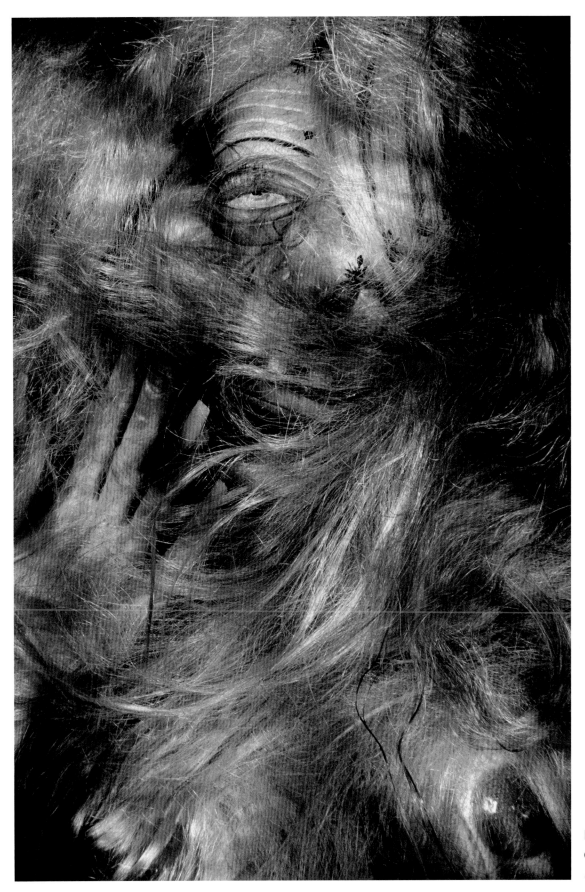

Plate 35
Cindy Sherman
Untitled #191, 1989

Plate 36
Inka Essenhigh
Green Goddess I, 2009

Plate 37
Inka Essenhigh
Brush with Death, 2004

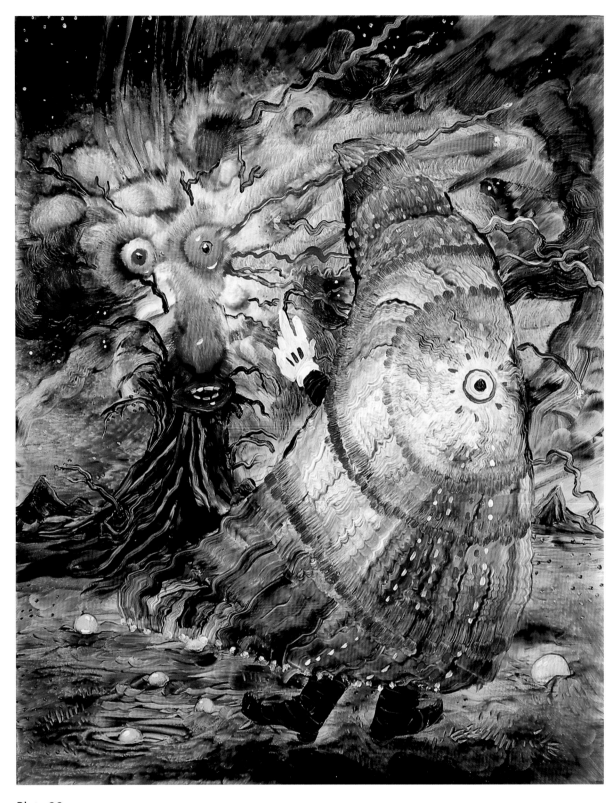

Plate 38
Andre Ethier
Untitled, 2007

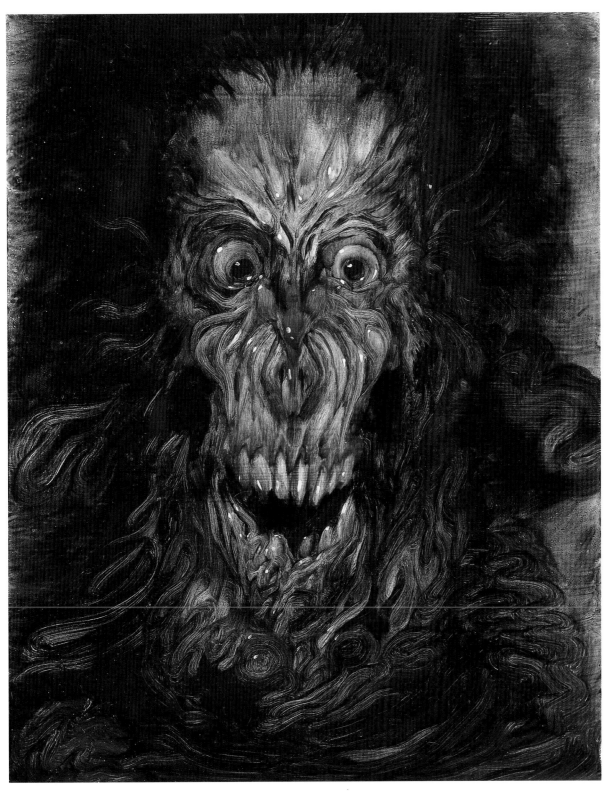

Plate 39
Andre Ethier
Untitled, 2007

Plate 40
Chapman Brothers
Untitled from the portfolio "Exquisite Corpse," 2000

Plate 41
Chapman Brothers
Untitled from the portfolio "Exquisite Corpse," 2000

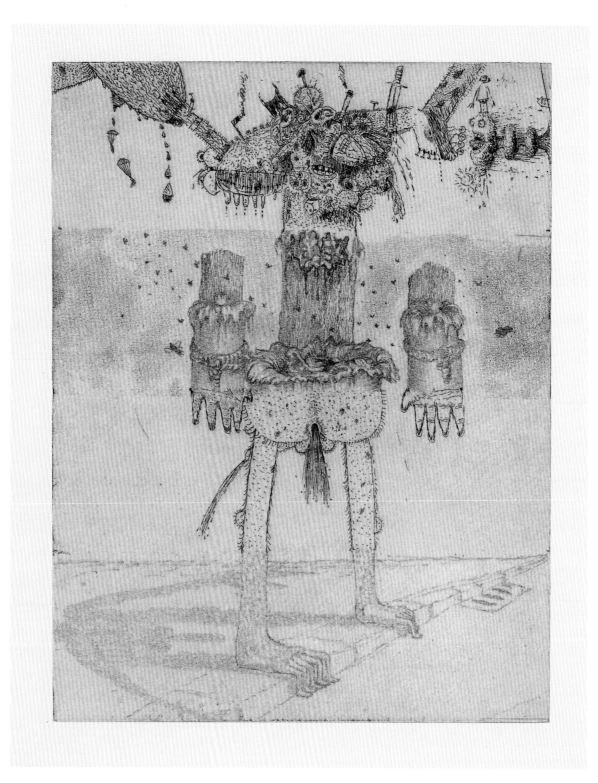

Plate 42
Chapman Brothers
Untitled from the portfolio "Exquisite Corpse," 2000

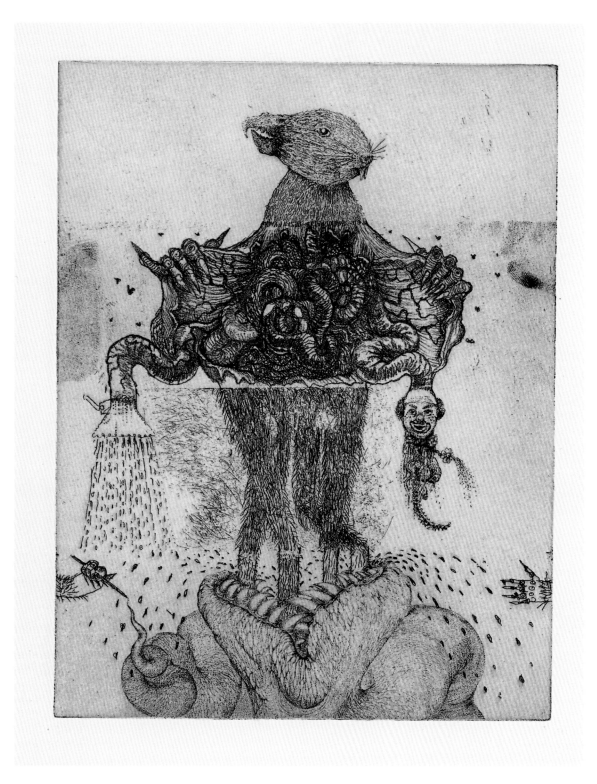

Plate 43

Chapman Brothers

Untitled from the portfolio "Exquisite Corpse," 2000

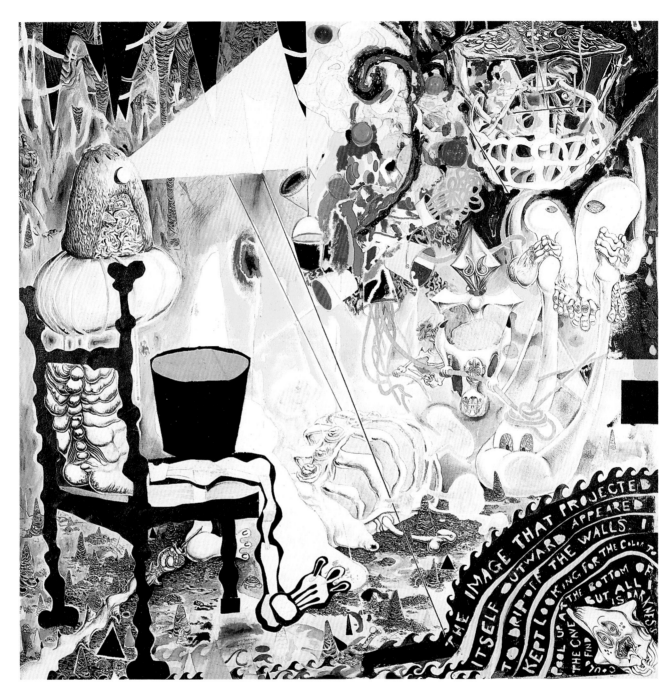

Plate 44
Trenton Doyle Hancock
Las Luces, Looses, and Losses, 2005

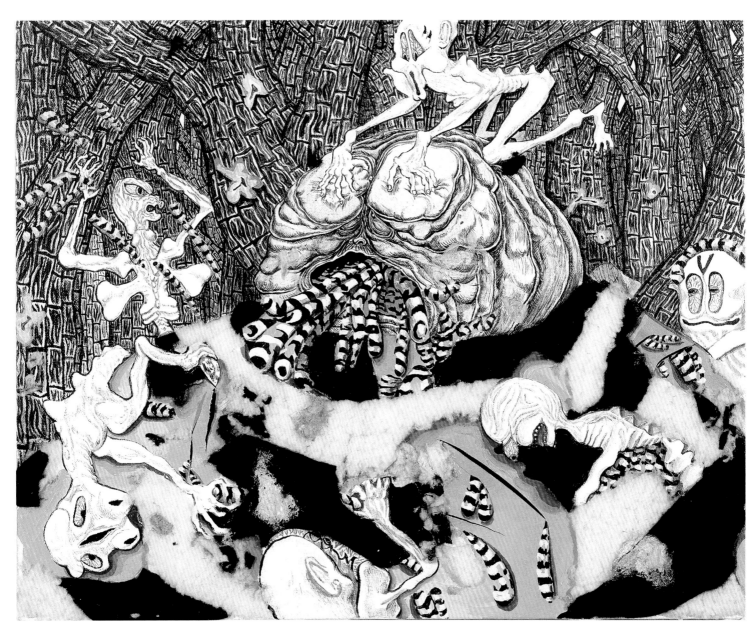

Plate 45
Trenton Doyle Hancock
Vegans Do Their Dirtiest Work, 2002

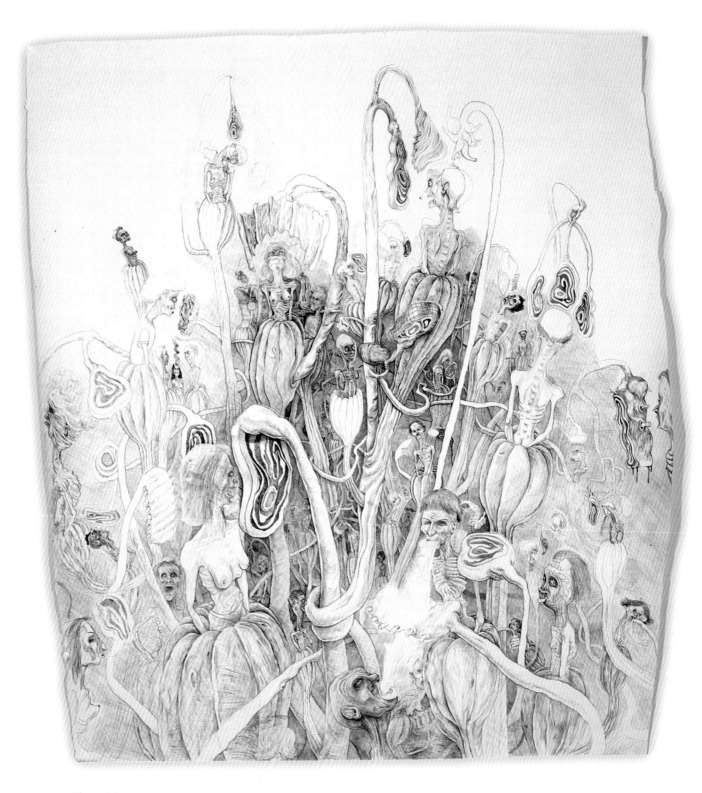

Plate 46
Trenton Doyle Hancock
Vegan Meat Training, 2000–2001

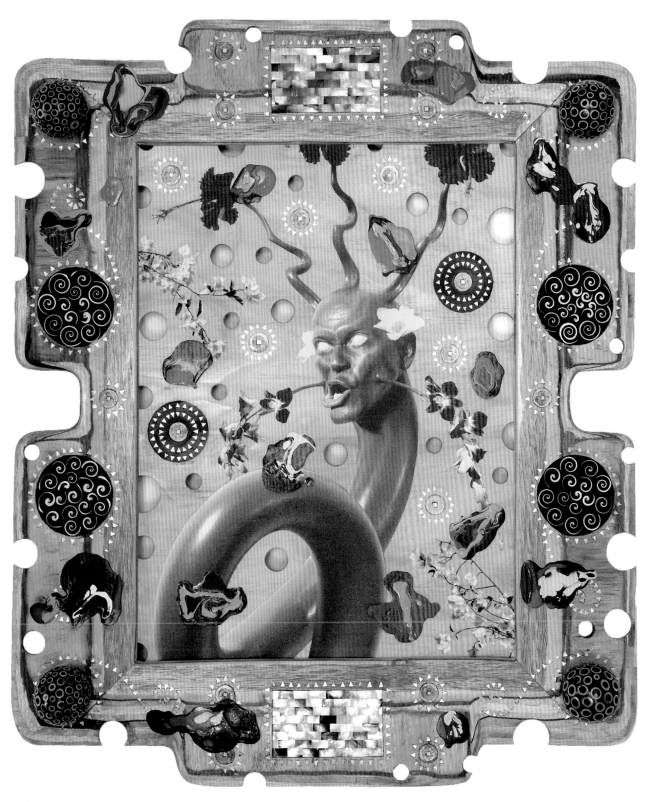

Plate 47
Ashley Bickerton
Snake-Head Painting, 2008

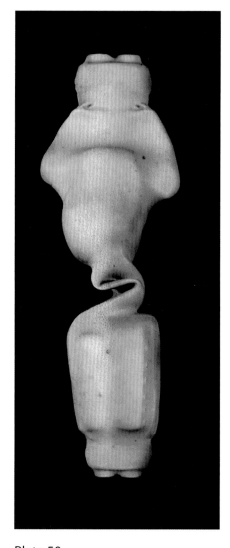

Plate 48
Aziz + Cucher
Chimera #1, 1999

Plate 49
Aziz + Cucher
Chimera #3, 1999

Plate 50
Aziz + Cucher
Chimera #8, 1999

Plate 51
Suzanne Anker
Water Babies, 2004–2006

Plate 52
Patricia Piccinini
When My Baby, 2005

Plate 53
Patricia Piccinini
In bocca al lupo, 2003

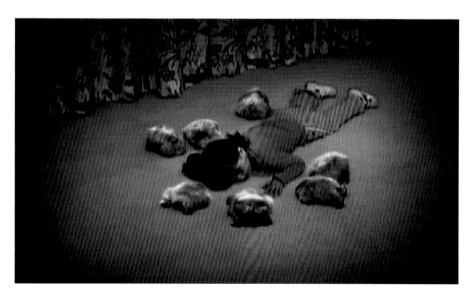

Plate 54
Patricia Piccinini
The Gathering, 2008

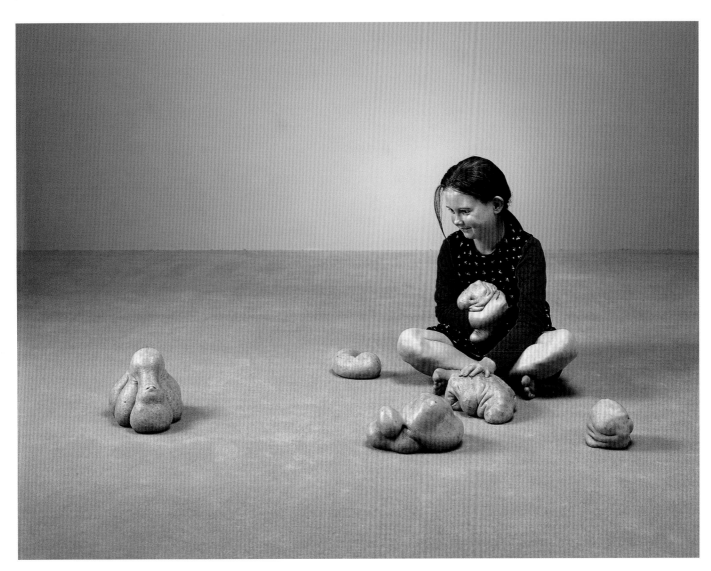

Plate 55
Patricia Piccinini
Still Life with Stem Cells, 2002

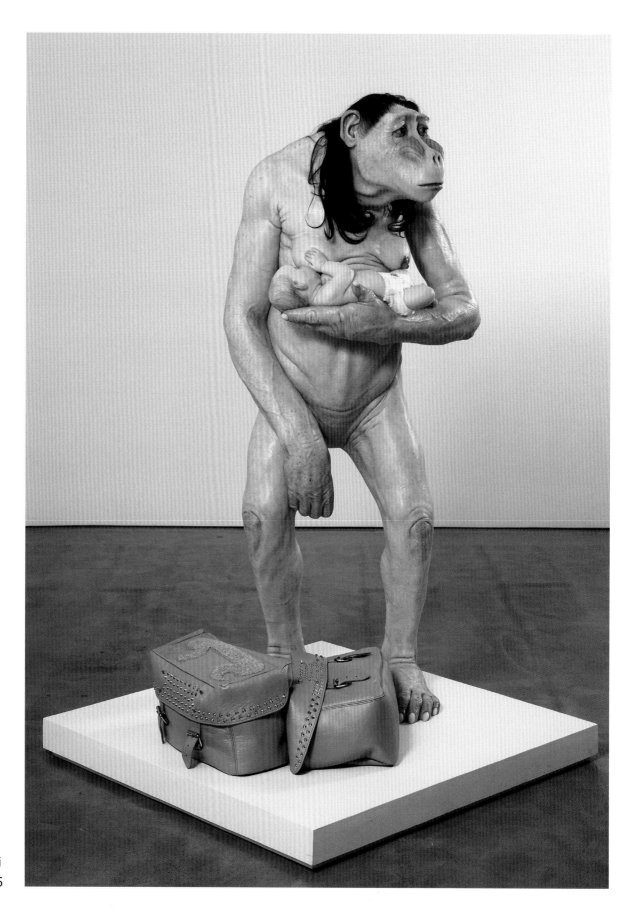

Plate 56
Patricia Piccinini
Big Mother, 2005

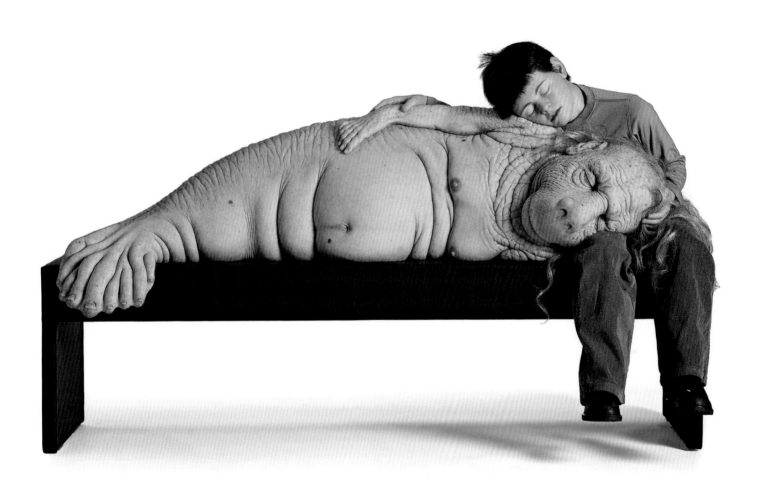

Plate 57
Patricia Piccinini
The Long Awaited, 2008

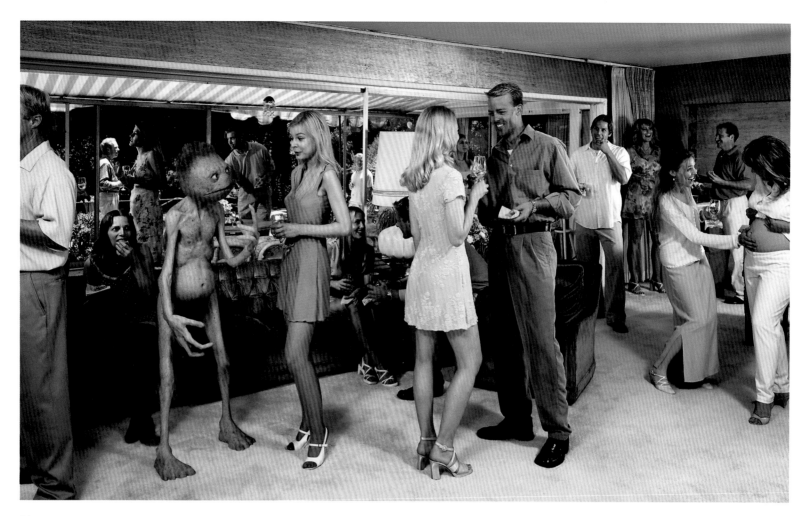

Plate 58
Charlie White
Cocktail Party, 2001

Plate 59
Charlie White
Getting Lindsay Linton, 2001

Plate 60
Janaina Tschäpe
Veratrum Bulbosas (from *Melantropics*), 2006

Plate 61
Janaina Tschäpe
Glandulitera Maris (from *Melantropics*), 2005

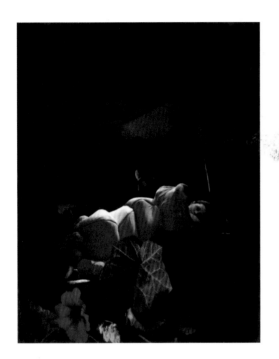

Plate 62
Janaina Tschäpe
A Botanist's Dream 1, 2005

Plate 63
Janaina Tschäpe
A Botanist's Dream 3, 2005

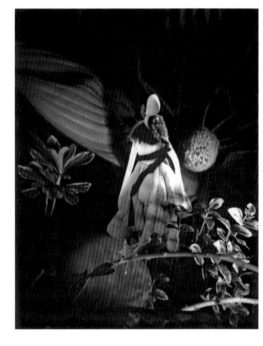

Plate 64
Janaina Tschäpe
A Botanist's Dream 5, 2005

Plate 65
Janaina Tschäpe
A Botanist's Dream 6, 2005

Plate 66
Janaina Tschäpe
A Botanist's Dream 8, 2005

Plate 67
Janaina Tschäpe
A Botanist's Dream 9, 2005

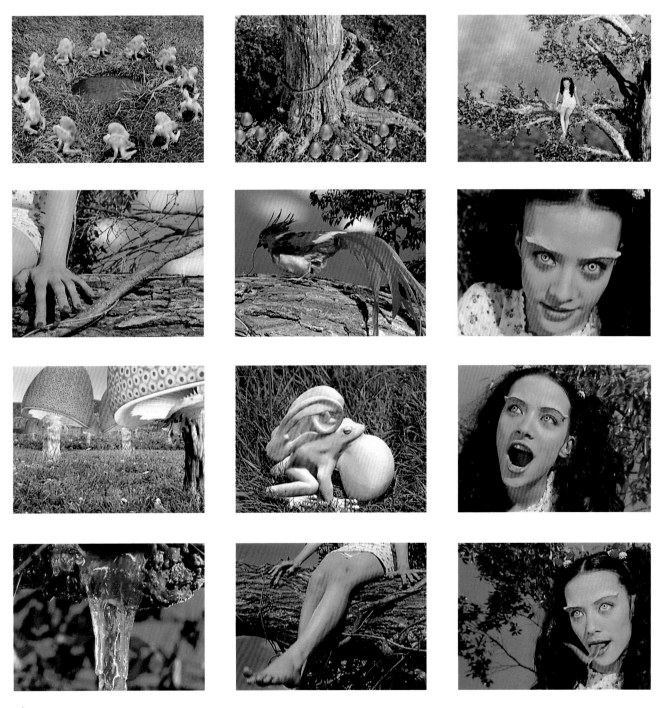

Plate 68
Motohiko Odani
Rompers, 2003

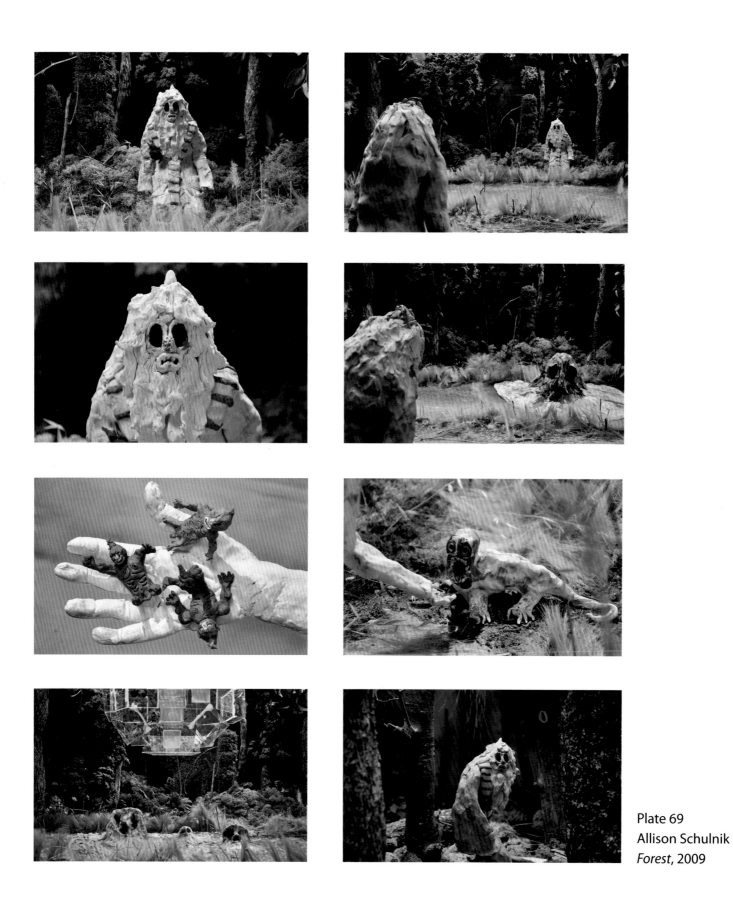

Plate 69
Allison Schulnik
Forest, 2009

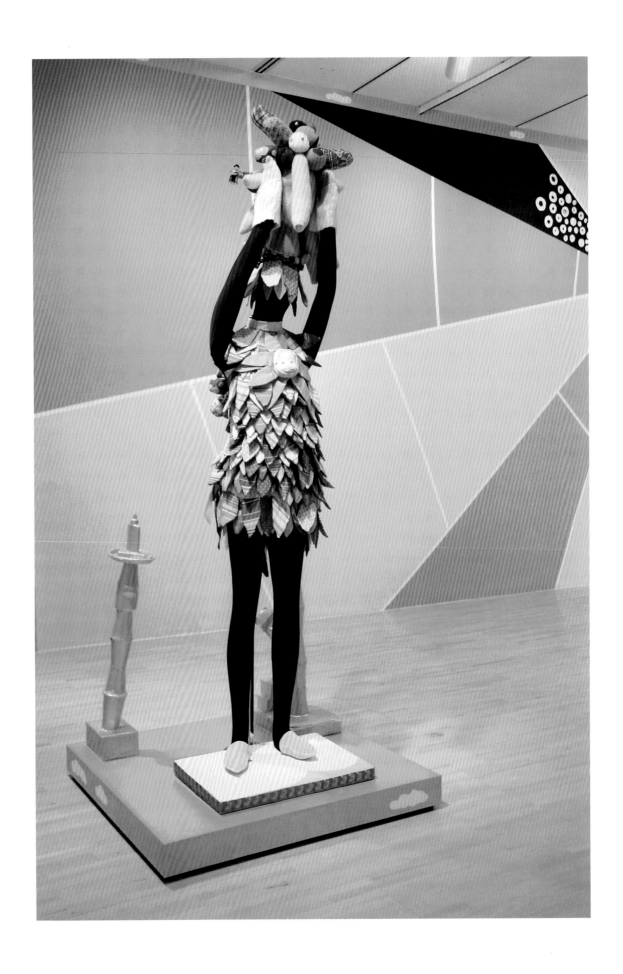

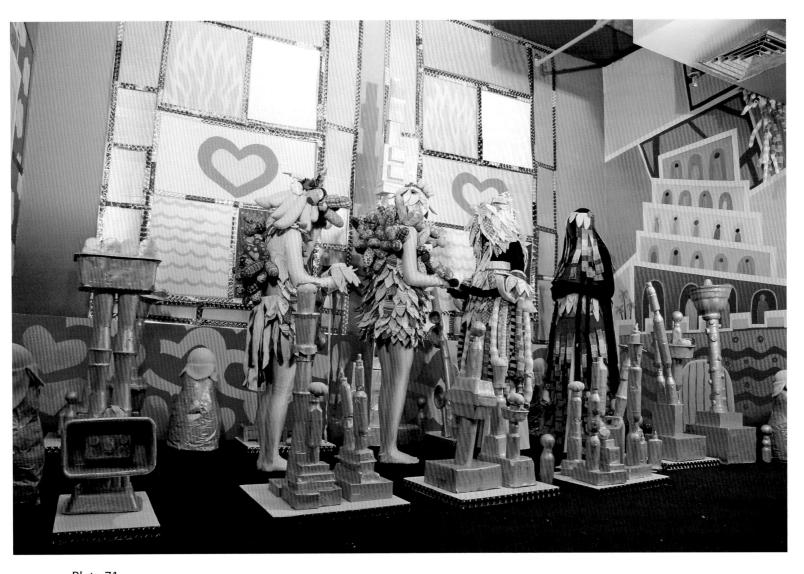

Plate 71
Saya Woolfalk (in collaboration with Rachel Lears)
No Place, 2008

Plate 70
Saya Woolfalk (in collaboration with Rachel Lears)
No Placean Self (female/male) (detail of *No Place*), 2008

David Altmejd
*Untitled (Man's Hard Idea Comes Out
of His Head)*, 2007
Foam, resin, feathers, cloth, paint, and glass
eyes, 27 ½ x 20 ½ x 19 in.
Collection of Louise Déry
Plate 33

David Altmejd
Werewolf 1 (Loup-garou 1), 2000
78 ¾ x 91 ⅜ x 96 in.
Wood, paint, synthetic hair, Plexiglas, lighting
system, plaster, polymer clay, acetate, Mylar,
jewelry, and glitter
Collection of the Gallery of the University
of Quebec, Montreal. Purchased with the
support of the York Wilson Endowment Award,
administered by the Canada Council for the
Arts, and with a gift of the artist
Plate 32

Suzanne Anker
Water Babies, 2004–2006
Twelve digital prints on watercolor paper,
24 x 36 in. each
Collection of the artist, New York
Plate 51

Aziz + Cucher
Chimera #1, 1999
C-print on aluminum, 60 x 30 in.
Courtesy of the artists
Plate 48

Aziz + Cucher
Chimera #3, 1999
C-print on aluminum, 60 x 30 in.
Courtesy of the artists
Plate 49

Aziz + Cucher
Chimera #8, 1999
C-print on aluminum, 60 x 30 in.
Courtesy of the artists
Plate 50

Ashley Bickerton
Snake-Head Painting, 2008
Acrylic, oil, digital print, mother of pearl, and
coconut on wood, 36 ⅝ x 30 ¾ x 2 in.
Private collection, courtesy of Lehmann
Maupin Gallery, New York
Plate 47

Meghan Boody
Henry's Wives: In a Garden So Greene, 1998
Cibachrome, 53 x 56 in.
Edition of 12
Private collection, New York
Plate 22

Meghan Boody
*Henry's Wives: Jane Seymour:
"Bound to Obey and Serve,"* 1997
Cibachrome, 32 x 21 in.
Edition of 3
Batterman-Greenberg Collection
Plate 20

Meghan Boody
*Henry's Wives: Katheryne Howard:
"No Other Wish but His,"* 1997
Cibachrome, 32 x 21 in.
Edition of 3
Collection of Jennifer Mallin
Plate 19

Meghan Boody
*Henry's Wives: Katherine Parr:
"To Be Useful in All I Do,"* 1997
Cibachrome, 32 x 21 in.
Edition of 3
Collection of Susan and Edward Bralower
Plate 21

Meghan Boody
Psyche and Smut: The Assessment of Smut, 2000
Lightjet print, 56 ½ x 41 ½ in.
Courtesy Rick Wester Fine Art and Salomon
Contemporary, New York
Plate 26

Meghan Boody
Psyche and Smut: Psyche Enters, 2000
Lightjet print, 56 ½ x 41 ½ in.
Courtesy Rick Wester Fine Art and Salomon
Contemporary, New York
Plate 23

Meghan Boody
Psyche and Smut: Psyche's Tail, 2000
Lightjet print, 56 ½ x 41 ½ in.
Courtesy Rick Wester Fine Art
and Salomon Contemporary, New York
Plate 25

Meghan Boody
Psyche and Smut: Psyche Supernova, 2000
Lightjet print, 56 ½ x 41 ½ in.
Courtesy Rick Wester Fine Art
and Salomon Contemporary, New York
Plate 28

Meghan Boody
Psyche and Smut: Psyche Wakes, 2000
Lightjet print, 56 ½ x 41 ½ in.
Courtesy Rick Wester Fine Art
and Salomon Contemporary, New York
Plate 24

Meghan Boody
Psyche and Smut: The Snivels of Smut, 2000
Lightjet print, 56 ½ x 41 ½ in.
Courtesy Rick Wester Fine Art
and Salomon Contemporary, New York
Plate 27

Chapman Brothers
Untitled from the portfolio "Exquisite Corpse," 2000
Etching, 9 1/16 x 7 1/16 in. (plate),
18 1/8 x 14 15/16 in. (sheet)
Publisher: Paragon Press, London; Printer: Hope
(Sufferance) Press, London; Edition: 30
The Museum of Modern Art, Roxanne H. Frank
Fund, 1334.2000.1
Plate 40

Chapman Brothers
Untitled from the portfolio "Exquisite Corpse," 2000
Etching, 8 13/16 x 6 7/8 in. (plate),
18 1/8 x 14 15/16 in. (sheet)
Publisher: Paragon Press, London; Printer: Hope
(Sufferance) Press, London; Edition: 30
The Museum of Modern Art, Roxanne H. Frank
Fund, 1334.2000.14
Plate 41

Chapman Brothers
Untitled from the portfolio "Exquisite Corpse," 2000
Etching, 8 7/8 x 6 15/16 in. (plate),
18 1/8 x 14 15/16 in. (sheet)
Publisher: Paragon Press, London; Printer:
Hope (Sufferance) Press, London; Edition: 30
The Museum of Modern Art,
Roxanne H. Frank Fund, 1334.2000.15
Plate 42

Chapman Brothers
Untitled from the portfolio "Exquisite Corpse," 2000
Etching, 9 1/16 x 7 1/16 in. (plate),
18 1/8 x 14 15/16 in. (sheet)
Publisher: Paragon Press, London; Printer:
Hope (Sufferance) Press, London; Edition: 30
The Museum of Modern Art,
Roxanne H. Frank Fund, 1334.2000.17
Plate 43

Kate Clark
Bully, 2010
White wolf hide, clay, thread, pins, foam,
rubber eyes, wood, and paint, 80 x 42 x 48 in.
Courtesy of the artist
Plate 18

Marcel Dzama
La verdad está muerta / Room Full of Liars, 2007
Wood, glazed ceramic sculptures, metal,
and fabric, 64 ½ x 65 ¾ x 46 in.
Edition 2 of 5, + 2 artist's proofs
Courtesy of the artist and David Zwirner
Gallery, New York
Plate 13

Marcel Dzama
Welcome to the Land of the Bat, 2008
Wood, glazed ceramic sculptures, metal,
and fabric, 33 x 28 x 40 in.
Edition 5 of 5, + 2 artist's proofs
Courtesy of the artist and David Zwirner
Gallery, New York
Plate 14

Inka Essenhigh
Brush with Death, 2004
Oil on linen, 60 x 48 in.
Courtesy of the artist and 303 Gallery,
New York
Plate 37

Inka Essenhigh
Green Goddess I, 2009
Oil on canvas, 60 x 78 in.
Courtesy 303 Gallery, New York
Plate 36

Andre Ethier
Untitled, 2007
Oil on wood, 20 x 16 in.
Private collection, New York
Plate 38

Andre Ethier
Untitled, 2007
Oil on wood, 20 x 16 in.
Private collection, New York
Plate 39

Trenton Doyle Hancock
Las Luces, Looses, and Losses, 2005
Mixed media on canvas, 60 ¾ x 60 ¾ x 4 in.
Collection of Lisa and Stuart Ginsberg
(Frist Center only)
Plate 44

Trenton Doyle Hancock
Vegans Do Their Dirtiest Work, 2002
Acrylic and mixed media on canvas,
16 x 20 in.
Marc and Livia Straus Family Collection
Plate 45

Trenton Doyle Hancock
Vegan Meat Training, 2000–2001
Mixed media on paper, 53 x 46 in.
Collection of Jeanne and Michael Klein
(Winnipeg Art Gallery and
Glenbow Museum only)
Plate 46

Mark Hosford
Haunting 3, 2008
Digital video disc
Courtesy of the artist
Plate 29

Mark Hosford
Haunting 4, 2009
Digital video disc
Courtesy of the artist
Plate 30

Walter Martin and Paloma Muñoz
The Mail Boat, 2007
C-print on Plexiglas, 38 x 100 in.
Edition of 6
Courtesy of the artists and P.P.O.W. Gallery,
New York
Plate 17

Walter Martin and Paloma Muñoz
Traveler CLXXXVI, 2006
Glass, water, wood, and plastic, 9 x 6 x 6 in.
Courtesy of the artists and P.P.O.W. Gallery,
New York
Plate 16

Walter Martin and Paloma Muñoz
Traveler CCXXVIII, 2007
Glass, water, wood, and plastic, 9 x 6 x 6 in.
Collection of Cindy Chupak
Plate 15

Motohiko Odani
Rompers, 2003
Digital video disc, music by Pirami
Courtesy Yamamoto Gendai Gallery, Tokyo
Plate 68

Patricia Piccinini
Big Mother, 2005
Silicone, fiberglass, leather, studs, diaper,
and human hair, 72 x 24 x 20 in.
Heather and Tony Podesta Collection
Plate 56

Patricia Piccinini
The Gathering, 2006
Digital video disc
Courtesy of the artist
Plate 54

Patricia Piccinini
In bocca al lupo, 2003
Digital video disc
Courtesy of the artist
Plate 53

Patricia Piccinini
The Long Awaited, 2008
Silicone, fiberglass, human hair, leather,
plywood, and fabric, 36 ¼ x 59 ⅞ x 31 ½ in.
Collection of Penny Clive, Australia
Plate 57

Patricia Piccinini
Still Life with Stem Cells, 2002
Silicone, hair, acrylic resin, and leather;
dimensions variable
Heather and Tony Podesta Collection
Plate 55

Patricia Piccinini
When My Baby, 2005
Digital video disc
Courtesy of the artist
Plate 52

Paula Rego
Nursery Rhymes: Little Miss Muffett III, 1989
Etching and aquatint, 9 x 8 ½ in. (image), 20 ½
x 15 in. (sheet)
Edition 49 of 50
Marlborough Graphics, New York
Plate 11

Paula Rego
Nursery Rhymes: Old Mother Goose, 1989
Etching and aquatint, 12 ¾ x 8 ⅜ in. (image),
20 ½ x 15 in. (sheet)
Edition 49 of 50
Marlborough Graphics, New York
Plate 8

Paula Rego
Nursery Rhymes: Three Blind Mice II, 1989
Etching and aquatint, 8 ⅞ x 8 ⅜ in. (image),
20 ½ x 15 in. (sheet)
Edition 49 of 50
Marlborough Graphics, New York
Plate 10

Paula Rego
Nursery Rhymes: Who Killed Cock Robin I, 1989
Etching and aquatint, 12 ¾ x 8 ⅜ in. (image),
20 ½ x 15 in. (sheet)
Edition 49 of 50
Marlborough Graphics, New York
Plate 9

Paula Rego
Peter Pan: The Never Land, 1992
Etching and aquatint, 11 ½ x 17 ⅝ in. (image),
22 ½ x 28 ⅛ in. (sheet)
Edition 32 of 50
Marlborough Graphics, New York
Plate 7

Tom Sachs
Hours of Devotion, 2008
Pyrography, wood, and gold leaf,
49 x 47 x 5 ¼ in.
Courtesy of Sperone Westwater Gallery,
New York
Plate 12

Allison Schulnik
Forest, 2009
Digital video disc
Montreal Museum of Fine Arts, Purchase,
The Museum Campaign 1988–1993 Fund
Plate 69

Cindy Sherman
Untitled #151, 1985
Color photograph, 72 x 48 in.
Courtesy of Skarstedt Gallery, New York
(Winnipeg Art Gallery and
Glenbow Museum only)
Plate 34

Cindy Sherman
Untitled #191, 1989
Color photograph, 90 x 60 in.
The Broad Art Foundation, Santa Monica
(Frist Center only)
Plate 35

Yinka Shonibare, MBE
*The Sleep of Reason Produces
Monsters (America)*, 2008
C-print mounted on aluminum, 72 x 49 ½ in.
(image), 81 ½ x 58 x 2 ½ in. (frame)
Edition 3 of 5
Collection of James P. Gray II
Plate 31

Kiki Smith
Born, 2002
Lithograph, 68 ⅛ x 55 ¹¹⁄₁₆ in.
Publisher: Universal Limited Art Editions,
West Islip, NY; Printer: Universal Limited Art
Editions, West Islip, NY; Edition: 28
The Museum of Modern Art,
Gift of Emily Fisher Landau, 369.2002
Plate 3

Kiki Smith
Come Away from Her (after Lewis Carroll), 2003
Etching, aquatint, and drypoint
with watercolor additions, 46 x 70 in. (plate),
50 ½ x 74 in. (sheet)
Publisher: Universal Limited Art Editions,
West Islip and Bay Shore, NY; Printer: Universal
Limited Art Editions, West Islip and Bay Shore,
NY; Edition: 28
The Museum of Modern Art,
Gift of Emily Fisher Landau, 363.2003
Plate 5

Kiki Smith
Pool of Tears 2 (after Lewis Carroll), 2000
Etching, aquatint, and drypoint, with
watercolor additions, 47 ½ x 71 ¾ in. (plate),
51 x 74 ½ in. (sheet)
Publisher: Universal Limited Art Editions,
West Islip and Bay Shore, NY; Printer: Universal
Limited Art Editions, West Islip and Bay Shore,
NY; Edition: 29
The Museum of Modern Art,
 Gift of Emily Fisher Landau, 1529.2001
Plate 6

Kiki Smith
Rapture, 2001
Bronze, 67 ¼ x 62 x 26 ¼ in.
Artist's proof 1 of 1,
edition of 3 + 1 artist's proof
Courtesy of the artist and the Pace Gallery
Plate 4

Amy Stein
Predator, 2006
C-print, 37 ½ x 30 in.
Courtesy of the artist and Brian Clamp Gallery
Plate 1

Amy Stein
Watering Hole, 2005
C-print, 30 x 37 ½ in.
Courtesy of the artist and Brian Clamp Gallery
Plate 2

Janaina Tschäpe
A Botanist's Dream 1, 2005
Polaroid photograph, 10 x 8 in.
Courtesy of the artist and Sikkema Jenkins
Gallery, New York
Plate 62

Janaina Tschäpe
A Botanist's Dream 3, 2005
Polaroid photograph, 10 x 8 in.
Courtesy of the artist and Sikkema Jenkins
Gallery, New York
Plate 63

Janaina Tschäpe
A Botanist's Dream 5, 2005
Polaroid photograph, 10 x 8 in.
Courtesy of the artist and Sikkema Jenkins
Gallery, New York
Plate 64

Janaina Tschäpe
A Botanist's Dream 6, 2005
Polaroid photograph, 10 x 8 in.
Courtesy of the artist and Sikkema Jenkins
Gallery, New York
Plate 65

Janaina Tschäpe
A Botanist's Dream 8, 2005
Polaroid photograph, 10 x 8 in.
Courtesy of the artist and Sikkema Jenkins
Gallery, New York
Plate 66

Janaina Tschäpe
A Botanist's Dream 9, 2005
Polaroid photograph, 10 x 8 in.
Courtesy of the artist and Sikkema Jenkins
Gallery, New York
Plate 67

Janaina Tschäpe
Glandulitera Maris (from *Melantropics*), 2005
C-print, 40 x 50 in.
Courtesy of the artist and Sikkema Jenkins
Gallery, New York
Plate 61

Janaina Tschäpe
Veratrum Bulbosas (from *Melantropics*), 2006
C-print, 40 x 50 in.
Courtesy of the artist and Sikkema Jenkins
Gallery, New York
Plate 60

Charlie White
Cocktail Party, 2001
Photograph, 36 x 60 in.
Collection of Stéphane Janssen, AZ
Plate 58

Charlie White
Getting Lindsay Linton, 2001
Chromogenic development print
mounted on Plexiglas, 36 x 60 in.
Samuel P. Harn Museum of Art, University
of Florida, Gift of Martin Z. Margulies
Plate 59

**Saya Woolfalk (in collaboration
with Rachel Lears)**
No Place, 2008
Mixed media; dimensions variable
Courtesy of the artist
Plate 71

**Saya Woolfalk (in collaboration
with Rachel Lears)**
No Placean Self (female/male)
(detail of *No Place*), 2008
Mixed media, 82 x 20 x 18 in.
Courtesy of Barbara Shuster
Plate 70

INDEX

Page numbers in bold indicate illustrations.

CREDITS